IMAGES
of America

DETROIT'S
MEXICANTOWN

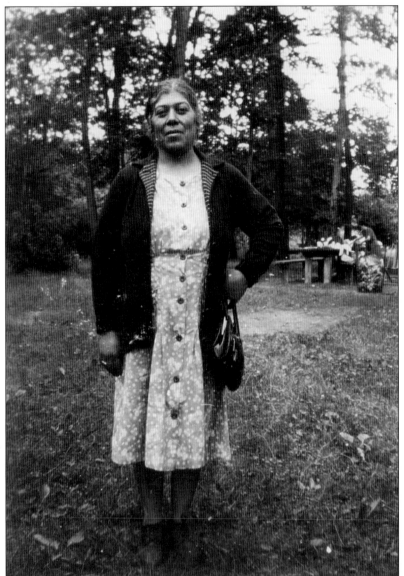

In 1920, Trinidad Cardenas Alvarez crossed the border at Eagle Pass, Texas, with her husband, Leonardo, and their three young children. Mexico was in turmoil. The revolution was ending and the events leading to the Cristero War were just beginning to develop. The future was bleak. Trinidad and her family acted as many others did: they packed their bags and moved north. The family story is that she had a pistol tucked in her skirt when crossing the border. Anyone who knew her would find that unremarkable since she was a no-nonsense kind of person. (Author's collection.)

ON THE COVER: Big band music was very popular in the 1940s. Latin music was performed by big bands in the United States. One local orchestra led by Al Gonzalez had a huge following in the Detroit area. (Courtesy of Sally B. Ramon.)

IMAGES
of America

DETROIT'S MEXICANTOWN

Maria Elena Rodriguez

Copyright © 2011 by Maria Elena Rodriguez
ISBN 978-0-7385-7802-6

Published by Arcadia Publishing
Charleston, South Carolina

Printed in the United States of America

Library of Congress Control Number: 2009943815

For all general information, please contact Arcadia Publishing:
Telephone 843-853-2070
Fax 843-853-0044
E-mail sales@arcadiapublishing.com
For customer service and orders:
Toll-Free 1-888-313-2665

Visit us on the Internet at www.arcadiapublishing.com

Dedicated to my parents, Louise and Florencio Perea. They met here. Because of them my roots run deep in both Detroit and Mexico.

CONTENTS

Acknowledgments		6
Introduction		7
1.	Overview of Mexicantown	11
2.	Pursuing the American Dream	19
3.	Progress	67
4.	Faith	77
5.	Social Organizations	91
6.	Arts and Culture	103
7.	Revival	109
8.	Latest Challenges	121

Acknowledgments

As a lifelong resident, I have always been fascinated with Detroit's history. I was also frustrated to rarely see any documentation of our Mexican immigrant existence. There are many dimensions to our community. Coming from a long line of merchants, I will focus on the businesses and everyday people.

It was difficult to obtain documents and photographs. Those who did permit me to use their photographs also shared their wonderful stories. My dad would always tell me about the bustling business district on Bagley Avenue. I still have fond memories of watching movies in Spanish at the Alamo Theatre and never leaving my seat. The usherette, Maria Arambula, ran a tight ship. Our lives were a mix of work, family, and faith. These photographs present what I want everyone to know about our place in the history of Detroit.

Special thanks go to Beatrice Gonzalez for being the first to step up with wonderful pictures and stories about meeting Pedro Infante, among others; Sylvia Salmon Ross for her commutes to meet with me and for some of the oldest photographs; Rachel Harness for the information and photographs compiled by her mom, the late Dr. Lucile Gajac; my cousins Rita Queen and Donald Ramirez for preserving great pictures of the Alvarez-Ramirez-Lopez clans; Sally Blancarte Ramon for allowing me to sit with her at her kitchen table; Aurelia Alfaro Savala and her husband, Pablo, for allowing me into their home and sharing his memories of the war in the Pacific; Ray Lozano for his wonderful photographs of family and sports; Laura Reyes Kopack and Carlos Alvarez for a glimpse of the faster-paced life at the Caucus Club/London Chop House; Rosa Ybarra for her family history and photographs in the old Plum Street neighborhood; Mary Segura for the group photographs of organizations; Raquel Gonzalez for her dad's business card; my dad, Florencio Perea, for answering a lot of my questions; and the Alonzo family for photographs of their father, Dave. This is a labor of love and a gift to my sons, Amado and Carlos Guadarrama, and their sons, Ricardo Florencio and Ramone Falcon. Although they are totally immersed in Detroit's culture, their core is clearly Mexican, and I know they will continue to pass on the values they learned at their grandparents' table.

Finally, a special thank-you goes to my husband, Maximo Rodriguez, for his editing skills and help in completing this book.

Introduction

The Statue of Liberty is a universal symbol of hope for all who seek a better life. Most stories about the pursuit of the American Dream begin at Ellis Island, where many immigrants disembarked. They were thousands of men and women, entire families, and even children traveling alone. Most came with little more than the clothes on their backs, a dream, and a belief that America could provide them with everything that their homeland could not. The very same can be said of the people who crossed the southern border. Immigration is such a part of America's history that most of us can relate to images of strangely clad newcomers streaming into New York's harbor. We do not always think of people wading across a shallow river and paying a couple of dollars at a US Customs booth.

Mexican families made sacrifices and hard choices—moving to a harsher climate, a different language and lifestyle. All this was done for the sake of their families. Mexican immigrants to America did not cross an ocean to get here, but they may as well have. At first, they never returned to Mexico to visit family or vacation. The Mexican Revolution of 1910 and the many years of social upheaval that followed there pushed them northward and kept them from immediately returning. The agricultural base of the Mexican economy was destroyed, creating massive unemployment. The opportunities for economic stability and a secure future in the United States were within their grasp, and they were not going to lose sight of either. Not until decades later was it common for them to trek back to Mexico to visit their families left behind.

Why did Mexicans settle in Detroit? They located there for the same reasons that Poles, Italians, Jews, Germans, and Arabs did. Job opportunities in Detroit's expansive industrial base—typified by Henry Ford's offer of $5 for a day's work—brought people from every part of the world, including Mexico. A common attraction was also the local geography. Michigan is surrounded by the Great Lakes and thus has an abundance of water. That is an important detail for people coming from countries lacking navigable rivers and affected by droughts. Detroit and Michigan were also very attractive to Mexicans wishing to avoid the overt discrimination against them so common in the Southwest. The first families who settled in Detroit were from central Mexico. They faced the immediate challenges of extreme climate, a new language, and a faster pace of life. Within the over 26 ethnic communities throughout the city, initially not speaking English was a great equalizer. Assimilation started as children began to go to school. Some things did not change in that process. That included the strong demand for basic ingredients to make real Mexican food. To meet this demand, the first commercial district of grocery stores, restaurants, and music shops was established. At first, it was called "la Bagley." Later, it would be known as Mexicantown.

Detroit began to change at the beginning of the 20th century. Then, the few restaurants that existed were vastly outnumbered by taverns and saloons that catered to a male customer base. Later, American diners and small tearooms started to dot the downtown and surrounding areas. These were followed by a few Chinese and Italian restaurants. By the early 1930s, a few Mexican restaurants had opened up in Corktown. They were on Porter Street, Michigan Avenue, and further

west on Bagley Avenue. These included Veracruz, on Bagley; Penjamo, on Michigan Avenue; Texas, on Clifford Street; Las Palmas, El Matador, and Mexican Village, the only original Mexican restaurant still in operation. By the mid-1930s, there were around 35 Mexican businesses on Bagley and Michigan Avenues. By the 1940s, tortilla factories opened in Detroit. La Michoacana and La Jalisciense have been making corn and flour tortillas for well over 60 years. Using real corn kernels and artisans to make their products, they provide the city and its surrounding communities with the taste of home. Today, there are over 1,000 Latino-owned enterprises within a three-mile radius of central Mexicantown. The number of established restaurants has risen from 15 to 45. This includes the new taquerias (home-style restaurants) that started to appear in the 1990s. In the early days, the business district included several Spanish-language movie theaters, nightclubs, hair salons, and retail stores. In those days, the city was prospering, and hardworking Mexican immigrant families contributed to that prosperity. The Baker Street trolley and, later, the Baker bus line ran from downtown Detroit on West Vernor Highway west to the Ford Rouge Plant in East Dearborn, Michigan. If you worked at Ford Motor Company or the other auto companies, your future was secure. An honest day's work for an honest day's pay led to a decent pension and a worry-free retirement. Jobs were plentiful, and it felt like they were all tied to the expansive auto industry. It was a great time to work and live in Detroit. During the war years, Mexicans, who generally value loyalty and patriotism, massively responded to the military call to duty. Detroit's Mexican immigrants and their grown children have participated in every American war dating back to World War I. This book will include references to World War II and the Korean War.

Just west of Corktown along Michigan Avenue in the shadow of the Grand Central train station was a busy commercial district that included Western Market, the counterpart of Eastern Market. In addition, there was a supermarket named Bi-Lo, the Azteca movie theater, Perea Meats, and other businesses that met the needs of southwest Detroit. The area was home to a diverse group that included Irish, Maltese, Puerto Rican, Appalachian white, and Southern black transplants as well as the Mexican community. Sadly, all that changed in the early 1960s when a large part of the neighborhood was bulldozed to accommodate the path of Interstate 75. This massive construction project almost devastated the community. Western Market was destroyed, and many businesses and homes were eliminated as well. Many locals sold their businesses and properties to the Michigan Department of Transportation and either retired or moved to the suburbs, but the majority stayed put. After all, where else could you find bakeries, candy shops, fabric stores, five-and-dime department stores, and theaters in one neighborhood? Well, if the I-75 freeway development was not devastating enough, more ruin was to come in the mid-1970s when General Motors decided to close three key auto plants in southwest Detroit. Plus, the Archdiocese of Detroit was merging the Catholic schools due to lower attendance. For more than 30 years, Mexicantown began reeling from the results of I-75 bisecting our community—especially on Bagley Avenue. The east side of the avenue was disconnected from the rest of the community, depending on where you were standing. Yet the longest-running restaurant in the entire district is Mexican Village, which is as popular today as it was in the early days.

In Mexico, there is a long tradition of incorporating art into everyday routines of life. Art always seems to soften the blows that a change of environment can bring. Because of this, it was imperative to the pioneers of our community that they not lose themselves in a new environment and that they maintain the traditions to pass on to the younger generation. Traditional events were mostly church-related, like the feast day of Our Lady of Guadalupe that takes place on December 12. The Christmas Posada, or *novena*, was celebrated at local parishes and the archdiocese encouraged the Mexican community to do so. These events were so popular that the early leaders decided to teach the children folkloric dances. Events were always family-oriented, and children were expected to attend most events.

Mexicantown has a clear sense of identity thanks to the number of social organizations that built the foundation for their community. Back in the late 1920s, several social organizations were founded, and a few actually owned the property or building that housed the group. There was always a real interest in staying in touch with the homeland via newspapers, radio, film, and,

later, television. Mexico's Independence Day is celebrated on September 16, and Cinco de Mayo commemorates an important battle that took place on May 5, 1862, that helped the Republic of Mexico defeat the French army and change the course of history in North America. These two holidays were the most popular, and the question was always who would control the activities and for how long. The Catholic Church always played a significant role in the Mexican community. Through adversity and challenges, many Mexican residents always relied on their faith, and moving to a northern city like Detroit was going to take a leap of faith in order to succeed. One of the first things that the community did was build its own Catholic church. Our Lady of Guadalupe on Roosevelt and Kirby Streets was not in the neighborhood, and that would later lead to the demise of that church. As the community grew, people attended several parishes in the area. The most popular was Most Holy Trinity, located on Porter and Sixth Streets and led by Father Clement Kern, who as the pastor for over 30 years was instrumental in the community settling in southwest Detroit. In the early days, Spanish-language masses were not encouraged, partly because all the ethnic communities that were in Detroit spoke their native languages, and that did not help them assimilate into American society. By the late 1980s, there was a realization that the new parishioners moving into Mexicantown and Detroit spoke little or no English. Families would attend with their children, and that meant holding more Spanish-language masses, not less. This trend continues and has added to the vibrancy of the community. Many of the early pioneers have passed away, and their families have moved on, but something interesting has occurred in the last few years—the grandchildren are moving into the neighborhood. They move back because of the ties they have or because of family or the low cost of real estate. They stay because they find that everything is so convenient, almost like the old times. So, in some ways, Mexicantown has come full circle.

One

Overview of Mexicantown

In the early 1920s, the first Mexican families began to settle in the residential sections around downtown Detroit. They were drawn to Detroit because of the many job opportunities available within its rapidly growing industrial base. With time, they moved farther southwest into the area known as Mexicantown.

The first families who settled in Detroit tended to not look back or talk about returning to Mexico. There were compelling reasons: many had escaped the Revolution of 1910; socioeconomic chaos ruled the day, displacing multitudes; and food, jobs, and peace were all scarce.

Meanwhile, in Detroit, there was a company hiring people with basic skills, and in some cases no skills, and paying $5 per day. Ford Motor Company was a big part of a local economy booming with jobs and brimming with optimism. People who moved to Detroit, Michigan, had the opportunity to become homeowners and provide a safe secure future for their families. There were no more worries about droughts if surrounded by the Great Lakes. And by moving as far north as Michigan, Mexicans escaped the overt and violent discrimination in the American Southwest.

The original Mexicantown business district's boundaries were Clark, Wabash, Sixteenth, and Lafayette Streets. It was centered on Bagley Avenue. Initially, there were around 30 Mexican-owned enterprises on Bagley and Michigan Avenues. Today, the common perception is that the core of southwest Detroit is Mexicantown. Within a three mile radius, there are now over 1,000 small, family-owned businesses.

There are several versions of the origin of the term "Mexicantown." A former officer of the Hispanic Business Alliance has said that a contractor who once installed new sidewalks and curbs on Bagley Avenue commissioned Tony Martinez, owner of Disenos, to create wrought iron signs that had images of charros and the name "Mexicantown." They were attached to lampposts in front of each business on Bagley Avenue, and the idea of Mexicantown was instantly embraced.

The Mexican community has left a huge imprint on Detroit. Despite setbacks, it continues to thrive in southwest Detroit (SWD), a historically diverse area. It has been home to African Americans, Appalachians, Europeans, Latinos, and Middle Easterners. Within this rich mixture of peoples and cultures, Mexican immigrants have built a strong and vibrant community.

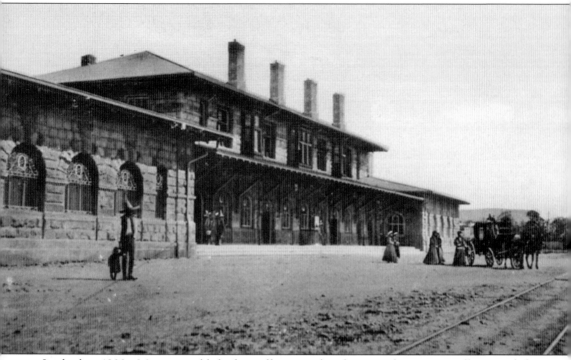

In the late 1800s, Mexico established an effective railroad system that strategically crossed the country, including the haciendas where workers toiled under harsh conditions. It was the popular form of transportation before and during the Mexican Revolution of 1910. It was to be a preferred mode of transportation for people looking to make a life in El Norte. This railroad station is located in the heart of the country in Queretaro, Mexico. (Author's collection.)

It became very popular to have studio photographs taken. Before, only the wealthy could afford to commission portraits. Now, middle- and working-class families could do the same. Here, little Teresa Perea Rodriguez poses in the first of many portraits that would mark important moments in her life. (Author's collection.)

Alfonso Fierro Contreras moved from Chihuahua, Mexico, to Los Angeles, California, in 1918. He settled there and raised a tight-knit family. He was active in his community and liked to help others. Subsequent generations moved away for a variety of reasons. Bringing along the family's activist tradition, his eldest grandson settled in Detroit. (Courtesy of Maximo Rodriguez Fierro.)

Trinidad Cardenas Alvarez was widowed with six children in 1926. She later married Arcadio Mendoza, a native of Pastor Ortiz, Michoacan. She had two more children with Mendoza—Maria Luisa and Manuel. All of her children remained in Metro Detroit. Arcadio lived in Detroit until Trinita passed away. He then moved back to his hometown in Mexico. (Author's collection.)

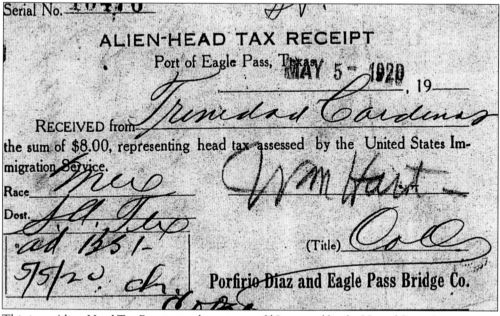

This is an Alien-Head Tax Receipt in the amount of $8 assessed by the United States Immigration Service. It was issued in 1920 to Trinidad Cardenas at the Porfirio Diaz and Eagle Pass Bridge Co. Entry to the United States at that time was an uncomplicated and brief stop at the border. (Author's collection.)

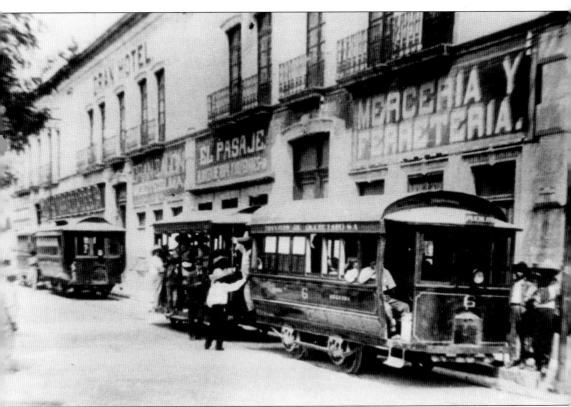

In 1908, under Gen. Porfirio Diaz's leadership, Mexico was modernizing and clearly poised to be competitive in the industrial age. Unfortunately, only the privileged few would benefit, and the masses would not. This photograph typifies the bustling business district of downtown Queretaro. Trolley cars transported people through the city. (Author's collection.)

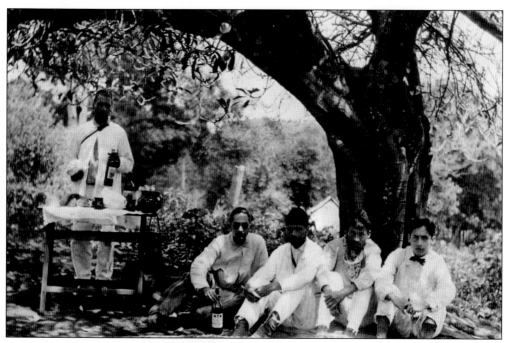

This photograph of a group of men relaxing at a roadside stand was taken in 1918. What stands out is that the young man on the far right is dressed up with a bow tie and possibly wearing the rural, indigenous style of pants like the rest of the men. It was a chaotic and traumatic time in Mexico. (Author's collection.)

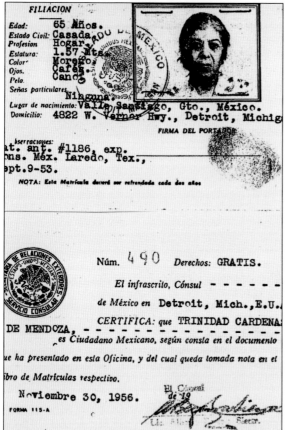

Trinidad Cardenas de Mendoza was a legal resident of the United States, but as a Mexican citizen she was required to register with the Mexican government at the Mexican consulate in 1956. Her *matricula* expired on September 9, 1953. Mendoza rarely traveled back to Mexico, but it appears that she was about to do so and needed to have her paperwork in order. The Mexican consulate in Detroit opened around 1919. (Author's collection.)

U. S. DEPARTMENT OF LABOR

NATURALIZATION SERVICE

NOTE.—A copy of this form will be furnished by the clerk of the court, the Chief Naturalization Examiner, or the public-school teacher to each applicant for a declaration of intention, so that he can at his leisure fill in the answers to the questions. After being filled out the applicant should take the form to the office of the clerk of court to be used by him in properly filling out the declaration. Care should be used to state as near as can be remembered the day, month, and year of arrival, as well as the name of the vessel on which the alien emigrated to this country.

TO THE APPLICANT.—The fee of one dollar required by law for the declaration, must be paid to the clerk of the court before he commences to fill out the declaration of intention. No fee is chargeable for this blank, and none should be paid for assistance in filling it out, as the Naturalization Examiner or the public-school teacher will help you free of charge.

My name is _Leonardo J. Alvarez_ Age: _33_ years.
(Alien should state here his true, original, and correct name in full.) (Give age at last birthday.)

Also known as _____
(If alien has used any other name in this country, that name should be shown on line immediately above.)

Occupation: _Laborer_

Color: _Braun_ Complexion: _____

Height: _5_ feet _4_ inches. Weight: _130_ pounds.

Color of hair: _Black_ Color of eyes: _Braun_

Other visible distinctive marks: _____
(If no visible distinctive marks, so state.)

Where born: _San Diego_, _Gto._ _Mexico_
(City or town.) (Country.)

Date of birth: _November_, _6_, _1890_
(Month.) (Day.) (Year.)

Present residence: _#1423 Lafayette St._, _____, _____
(Number and street.) (City or town.) (State, Territory, or District.)

Emigrated from: _Laredo Tex_ _I. G. M. Railway Company_
(Place where alien got on ship or train to come to the United States.) (Country.)

Name of vessel: _I. G. M. Railway Co._
(If the alien arrived otherwise than by vessel, the character of conveyance or name of transportation company should be given.)

Last place of foreign residence: _____, _Mexico City_
(City or town.) (Country.)

*I am _yes_ married; the name of my {wife/husband} is _Trinidad Carcoup_ {she/he} was
*born at _Valle Santiago Gto._; and now resides at _1423 Lafayette St._

I am now a subject of and intend to renounce allegiance to _____
(Write name and title of sovereign and country of which now a subject; or if citizen of a Republic, write name of Republic only.)

I arrived at the port of _Laredo Texas_, _Tx._
(City or town.) (State or Territory.)

on or about _November_, _6_, _1890_
(Month.) (Day.) (Year.)

* NOTE TO CLERK OF COURT.—The two lines indicated by the * contain information which is provided for by blanks on the latest declaration of intention form; until such time as you may be supplied with forms containing these blank spaces the information called for herein should be inserted immediately ABOVE the twelfth line, which begins "It is my bona fide intention," etc., as requested in circular letter of January 5, 1916.

A copy of Leonardo Alvarez's application for naturalization was issued after 1920. Though the application was improperly filled out, it apparently did not affect the process. The application fee was only $1. (Author's collection.)

Colonial buildings in Queretaro date back to the 17th century and were rarely sold to any outsiders. They were passed on to children and grandchildren, and to date most of the homes are still kept in the family. These were houses that at times took up full square blocks and included orchards and gardens. The privileged really did live a life filled with the best of everything. This is an example of the disparity that caused the revolution. (Author's collection.)

Two

Pursuing the American Dream

The history of Detroit's Mexican community is characterized by a sheer will and determination to live "a better life." It is the same immigrant story lived out by the many ethnic groups who settled in Detroit.

The one difference with the newer Mexican families is that they may harbor a dream to earn just enough to return and live a better life in Mexico. The possibility is real because of Mexico's relative proximity. Once settled, and with children in school, that dream fades. For those who have the means to travel, annual trips during the winter have become a routine. They can return to visit parents and enjoy the holidays in Mexico. What keeps them here is the simple desire to grow families in a country without rigid social classes. For all of its progress, Mexico is still a nation where class and name have a lot to do with one's future. That is a major consideration for workers leaving Mexico for the United States. Some Mexican immigrants were and are content with a steady job that provides a pension at the end of prime work years. Others have wanted more and actively pursued it. Successful entrepreneurs from this community are setting an example for future generations. That option to choose a path from many is a big part of the American Dream.

This chapter is a glimpse of the ordinary families who made extraordinary sacrifices to provide stability and a future. They contributed to the bright tapestry of Detroit and continue to do so. Many ethnic communities moved farther out of Detroit and established themselves in Macomb and Oakland Counties. The beauty of Detroit's Mexican community is that it has been replenished by even more Mexican families moving into southwest Detroit—families that moved out to the suburbs still have an emotional link to Mexicantown. Whether it is attending Sunday mass at their favorite parish, shopping in the district, or going to events, there is always something that brings them back. In addition, there are many young adults moving back to their grandparents' neighborhood and thereby contributing to the revitalization of Detroit.

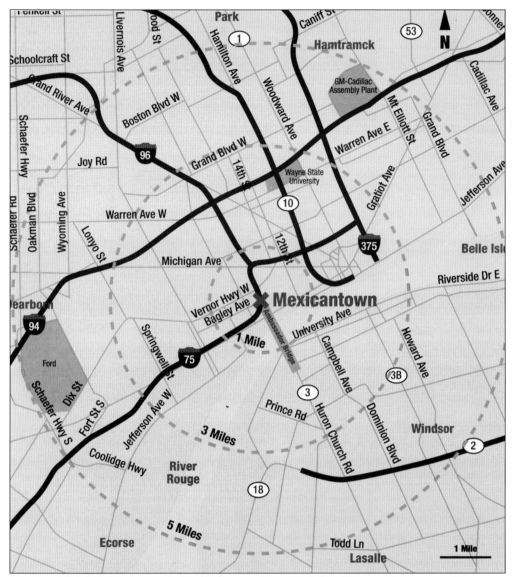

The first Mexican families settled in Detroit in the early 1900s. They settled in west downtown and Corktown. The community would refer to their business district as La Bagley. Bagley Avenue is where many Mexican owned businesses flourished. The term Mexicantown was originated by members of the Hispanic Business Alliance in the 1980s. Mexicantown is a vibrant part of the city of Detroit. This map shows how all of the freeways converge at Bagley Avenue and Twenty-first Street—the original heart of the Mexican community. Mexicantown is a community that prides itself for its diversity and continues to draw people. (Courtesy of Mexicantown Community Development Corporation.)

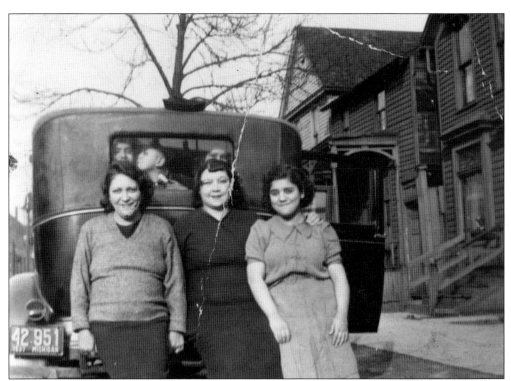

The early Mexican families settled in downtown Detroit's residential area near the oldest Irish neighborhood just to the west, known as Corktown. In 1937, the Ybarra family poses behind the family car. Notice the wooden houses built close together. (Courtesy of Rosa Ybarra.)

This photograph was taken on Plum Street and Second Avenue, where the Ybarra family had its own enclave around 1937. It was common and comforting to know that one's grandparents, aunts, and cousins all lived next to each other. The cold, hard winters were just one example of the many initial obstacles the Mexican community overcame. (Courtesy of Rosa Ybarra.)

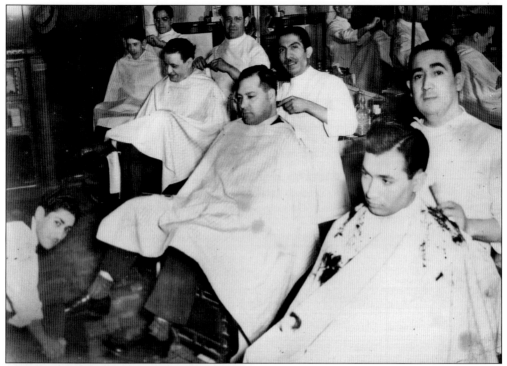

Bagley Avenue became a bustling commercial district that extended from Sixth Avenue to West Grand Boulevard. The businesses included the Medrano Brothers full-service barbershop on Bagley Avenue. As their business grew, the Medrano brothers partnered with Gerardo Alfaro, owner of La Colmena market, and other investors to provide parks and green space for Mexican families to enjoy. (Courtesy of Sylvia Salmon Ross.)

Gerardo Alfaro opened a small grocery store on Bagley Avenue and Sixteenth Street. He believed that the Mexican community needed to invest in its future in Detroit. He partnered with six investors and purchased land in Woodhaven to build a private park and banquet facility similar to other ethnic communities in Metro Detroit. It was a time-honored way of giving the community a haven to hold events and to celebrate successes. (Courtesy of Aurelia Alfaro Savala.)

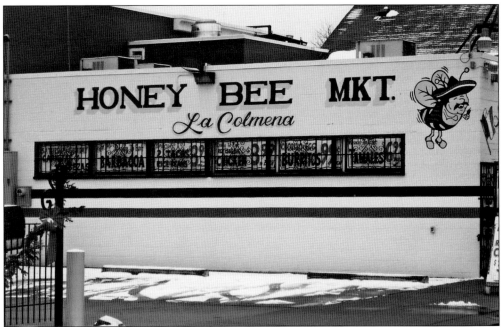

Maria and Gerardo Alfaro opened the Honeybee Market in 1956. The original building is located on Bagley Avenue at Sixteenth Street. The family home was one block away. They took advantage of the many amenities that the neighborhood had to offer. They did not have to leave the neighborhood because everything was available to them, including a trolley car that traveled on Bagley Avenue from downtown Detroit to South Dearborn. Their son Alex Alfaro and his wife, Francisca, took over the family business. From 1981 to 1995, Francisca operated the store after her husband's passing. (Author's collection.)

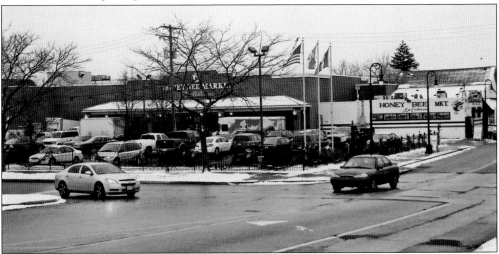

Granddaughter Tomasita Alfaro-Kohler and her husband, Ken Kohler, continued the tradition of providing top-quality groceries by purchasing La Colmena market. In 1996, they invested in Detroit by expanding the store from 5,000 square feet to 12,000 square feet. They sell a wide variety of grocery and specialty items. A large parking lot makes the business convenient for customers. It is a third-generation family enterprise that is part of the very strong Mexicantown tradition. (Author's collection.)

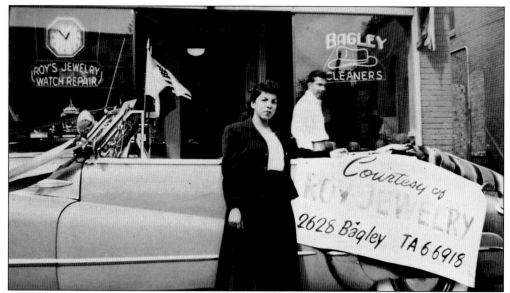

Sally Ramon poses in front of the family business as the Mexican Independence Day Parade starts on Bagley Avenue. Roy's jewelry and watch repair shop was located next door to Mexican Village restaurant on Bagley Avenue at Eighteenth Street. Rogelio Ramon first worked in the restaurant kitchen. He saved up enough to open the shop next door and later turned it into Roy's Record Shop. The Ramons bought a house on the street behind the shop, and Sally continues to live there. She grew up in the neighborhood and walked to school. She later walked to her business, and walked her children to their school. Back then, Detroit was more of a pedestrian-friendly town. (Courtesy of Sally B. Ramon.)

Cesar Gonzalez is in front of what appear to be three businesses in one building. To the far right is the original storefront of the Mexican Village Restaurant on Bagley Avenue at Eighteenth Street. This corner had a dime store and a grocery store across the street from the restaurant as well as a barbershop, duplex, and hotel. It was all next door to Roy's watch repair shop. (Courtesy of Sally B. Ramon.)

In 1950, Rogelio Ramon (right) and Victor Salim pose in front of a decorated car preparing to participate in the Mexican Independence Day Parade. They are on Bagley Avenue, or La Bagley. The brick-paved street and rails are visible. The Baker Street Trolley ran on those tracks. (Courtesy of Sally B. Ramon.)

From left to right, Lola Tenorio, Mexican actor Antonio Badu, and Maria Segura are attending one of the many events celebrating Mexico's Independence Day on September 15. (Courtesy of Mary Segura.)

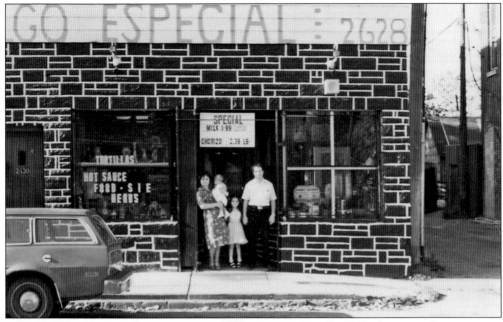

In 1980, the newest business on East Bagley Avenue was Algo Especial, owned and operated by Raul and Marta Hernandez. Here, the Hernandezes pose with their two daughters—Lucia and Rocio Hernandez. This building originally housed Roy's watch repair shop. Aside from the faux brick design, the facade is the same. (Author's collection.)

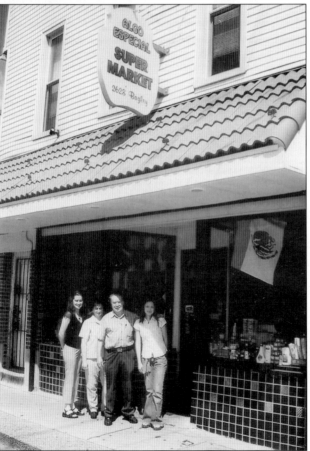

Around 2005, the Hernandez family reinvested in their store and had a facade renovation that preserved the integrity of the building. Lucia and Rocio grew up in the business and earned their college degrees. They and extended family members work in the store. This expanded grocery store now includes home-style foods made on the premises. It is truly a general store, where books, music, videos, herbs, religious items, cooking equipment, and items imported from Mexico can be purchased. (Author's collection.)

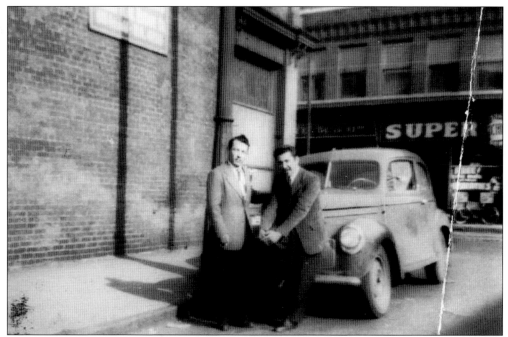

In 1946, Raymond Abundis (left) and an unidentified gentleman are posing just off of Bagley Avenue. Damaso and his son Raymond Abundis opened La Jaliscience tortilla factory on Bagley Avenue. This would be the second tortilla factory to open in Detroit and an indication that the community was growing. In 1947, Raymond Abundis bought the business from his father, and it has been making tortillas ever since. The family-run business included his wife, Oralia, and children Sergio, Norma, Myrna, and Gloria. They expanded their operations to include a new production facility that makes flour tortillas. (Courtesy of Sylvia Salmon Ross.)

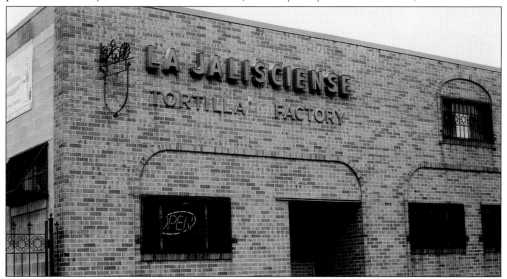

The exterior of La Jaliscience tortilla factory is located on Bagley Avenue between St. Anne and Eighteenth Streets. This 64-year-old, family-owned business continues to supply staple tortillas, specialty tortillas, *masa* (dough) for tamales, and other corn-based appetizers. (Author's collection.)

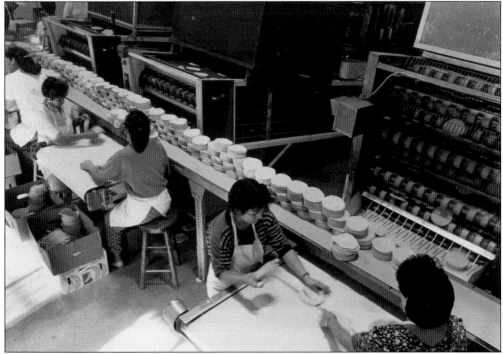

The actual process of making mass-produced corn tortillas still requires an artisanal touch, as seen here at the original La Jaliscience factory. (Courtesy of the Abundis family.)

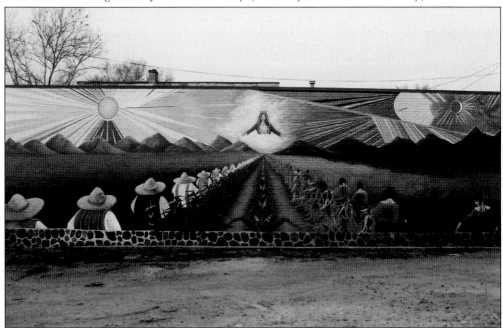

In addition to their commitment to providing fresh corn and flour tortillas to the community and their mainstream customer base, the Abundis family understands the importance of public art. They commissioned local artist Vito Valdez to paint a mural in their parking lot that depicts the history and importance of corn. (Author's collection.)

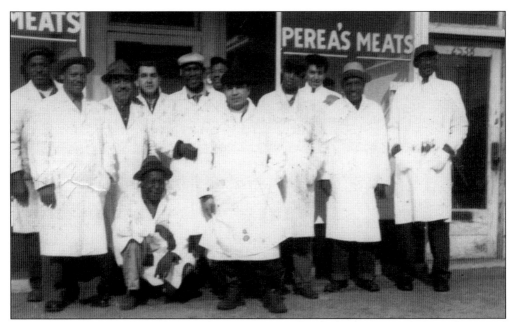

Perea's Meats store was located on Michigan Avenue and Eighteenth Street. This was the second store opened by Florencio and Ricardo Perea. The Perea brothers migrated to Detroit from Queretaro, Mexico, in 1950 and come from a long line of merchants. They opened their first store in Delray on Dearborn Street. In addition, they opened Fiesta Meats packinghouse in Eastern Market, next door to Butcher's Inn. In this photograph, Ricardo Perea is in the center and his father, Don Ricardo Perea, is the third person on the left. Florencio took this picture. (Courtesy of Ricardo Perea Gonzalez.)

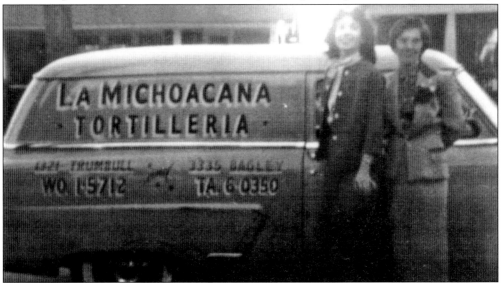

Alma and Betty pose in front of a La Michoacana Tortilleria delivery truck. In 1954, La Michoacana had two locations: one on Trumbull Avenue, and the other on Bagley Avenue. It was the first corn-tortilla factory in Detroit. Rafael Gutierrez and Concepcion Treviño de Gutierrez first opened their doors in 1942. Although Mr. Gutierrez was raised in Monterrey, Nuevo Leon, he named the business after his home state of Michoacan. Later on, Fernando Gutierrez purchased the Mexican Village restaurant that continues to be part of the Gutierrez legacy. (Courtesy of Lydia Gutierrez.)

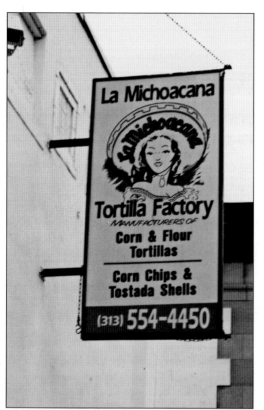

La Michoacana tortilla factory is one of the oldest businesses in Mexicantown. It continues as a family business run by daughter Connie Gutierrez and her family. It is still located on Bagley Avenue between Twenty-third and Twenty-fourth Streets, on the restaurant row. (Author's collection.)

Since the owners kept their doors open until early-morning hours, Mexican Village restaurant, located on the corner of Bagley Avenue and Eighteenth Street, was a popular meeting spot for after dance gatherings. In this picture taken in 1953, Luis Aguilar, a renowned Mexican film star, is seated at the head of the table in the dark suit, and standing behind him is Carmen Casillas. Sylvia Salmon (third from the left) sits next to Aguilar. The rest of the gentlemen are either part of his entourage or local guests. Carmen Casillas and her family were the original owners of Mexican Village restaurant. (Courtesy of Sylvia Salmon Ross.)

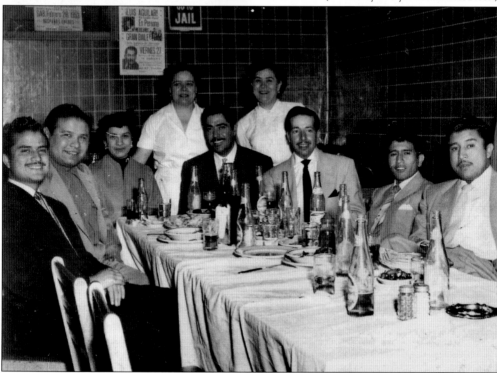

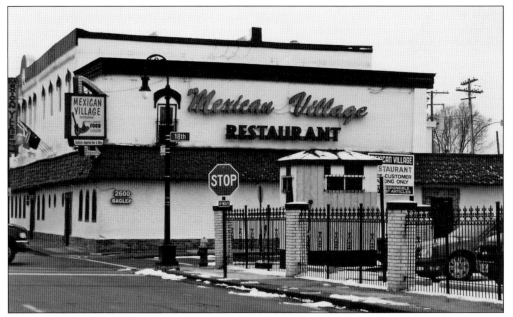

Mexican Village was purchased by its third and current owners, the Gutierrez family of La Michoacana tortillas. It is the longest-operating Mexican restaurant on Bagley Avenue and was a favorite place to see and be seen after popular dances or nightclubbing. The parking lot on the right used to be the site of a multiple-family unit, and next door was a hotel. (Author's collection.)

 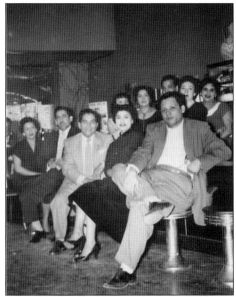

Many Mexican restaurants popped up in Corktown and farther south in what it now called Mexicantown. Penjamo Restaurant, named after a town in Michoacan, opened its doors on Michigan Avenue between Brooklyn and Eighth Streets. Above left, the owner, Ofelia Macias, is holding her cousin Rosalinda Ybarra in 1955. The interior shot of Penjamo Restaurant above right shows a casual setting for enjoying authentic Mexican food. This was a favorite location for the Ybarra family. They celebrated many major events here. (Courtesy of Rosa Ybarra.)

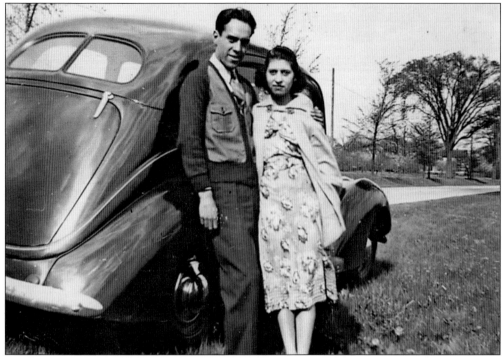

Catherine Alvarez and Gregorio Ramirez were married at a young age and settled around Bagley Avenue and Twelfth Street. Catherine enjoyed taking photographs of family and friends. She took plenty of her husband, known as "Grady." They loved to take short trips around the metro area. (Courtesy of Lopez-Ramirez family.)

Anthony Lozano (second from left) and friends are sitting alongside a road enjoying a summer afternoon. (Courtesy of Ray Lozano.)

This type of wooden house was common in Corktown and in Ste. Anne's parish. They are usually referred to as workmen's cottages or shotgun cottages. When this photograph was taken, the home belonged to Josephine Madrid. (Courtesy of Ray Lozano.)

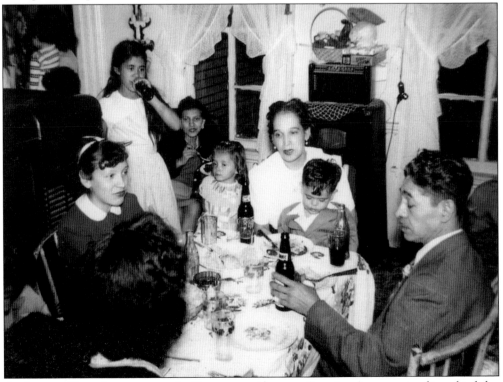

Anthony and Lupe Lozano are at the Carmona residence on Junction Avenue attending a birthday party for Richard Carmona. He is the little boy in the picture. (Courtesy of Ray Lozano.)

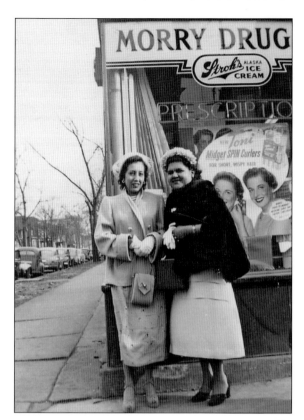

Mary Segura (left) and her unidentified friend are all dressed up on an early spring day. They are standing in front of Morry Drug on the corner of Bagley Avenue and Eighteenth Street. Most of Bagley was residential, with the exception of corner hubs like this one. Across the street is Mexican Village Restaurant, and directly across Bagley Avenue were a duplex and a hotel. (Courtesy of Mary Segura.)

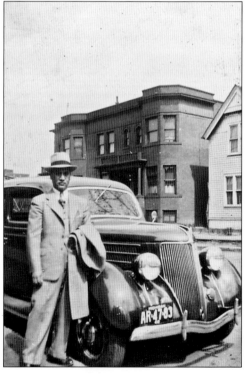

Anthony Alvarez poses in front of his car in the late 1930s on McKinstry Street. He was born in the state of Guanajuato and was brought to the United States with his parents and younger siblings in 1920. He was the eldest of four children and became very active in the early years of the Mexican community. (Courtesy of Lopez-Ramirez family.)

It was common to exchange at the very least a postcard with family and friends. This card was sent to wish the recipient a happy new year. It was written in 1929 and inserted in an envelope, so no postmark was on the actual card. (Author's collection.)

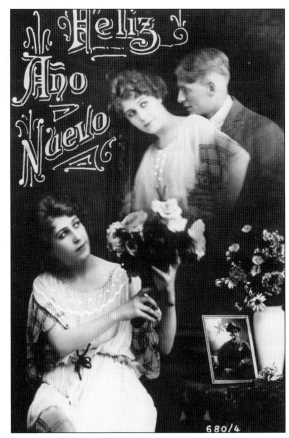

In 1930, a Mrs. Candia sent a postcard that was more of an affectionate note to her daughter who lived in Detroit. (Author's collection.)

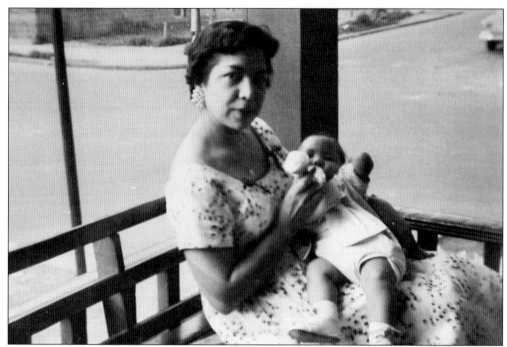

At the Ybarra enclave located on the corner of Fifth and Plum Streets, Carmen Ybarra sits on her porch and bottle-feeds her daughter Rosa. The corner is now the site of the MGM Casino complex. (Courtesy of Rosa Ybarra.)

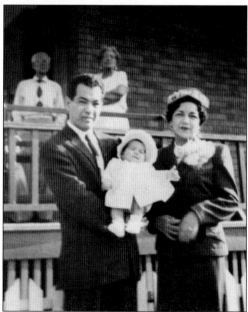

At left, Henry and Carmen Ybarra pose in front of the family complex on Fifth and Plum Streets. Mr. Ybarra is holding their baby girl, Rosalinda. The couple on the porch are baby Rosalinda's grandparents. At right, Torrence Aberaham (left) and Manuel Costello pose in 1955. These two crossing guards on the corner of Sixth and Porter Streets are from Most Holy Trinity School. (Courtesy of Rosa Ybarra.)

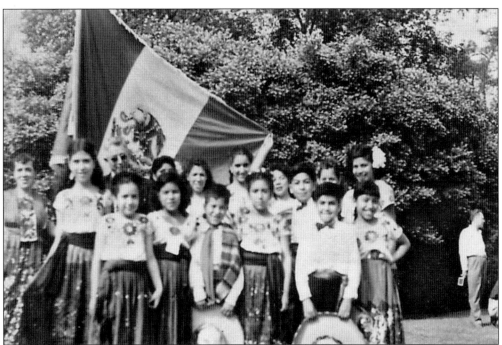

In 1956, a group of investors led by Gerardo Alfaro built a park that the Mexican community could enjoy. This dance group led by Maria Alcala (far left) performs at the park during a Mexican Independence Day celebration. San Juan de los Lagos Park was located in Brownstown Township at West and Telegraph Roads. The 22-acre park included a clubhouse with facilities and a dance hall. Unfortunately, the park was short-lived because there was no commitment from the group to manage and maintain the property. (Courtesy of Aurelia Alfaro Savala.)

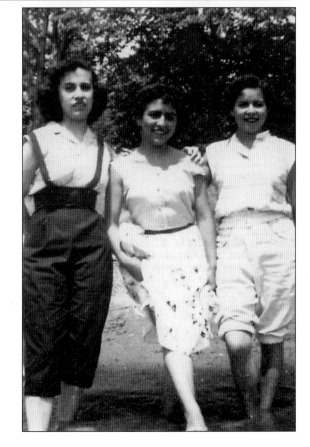

Aurelia Alfaro (far right) and her friends enjoy a summer afternoon at San Juan de los Lagos Park in the early 1950s. (Courtesy of Aurelia Alfaro Savala.)

Bob Flores is in front of J&J Confectionery store on the corner of Bagley Avenue and Beecher Street. (Courtesy of Ray Lozano.)

Micaela Salmon enjoyed driving the family car. She was outgoing, and both she and her husband, Genaro, befriended Diego Rivera and Frida Kahlo when they temporarily lived in Detroit. (Courtesy of Sylvia Salmon Ross.)

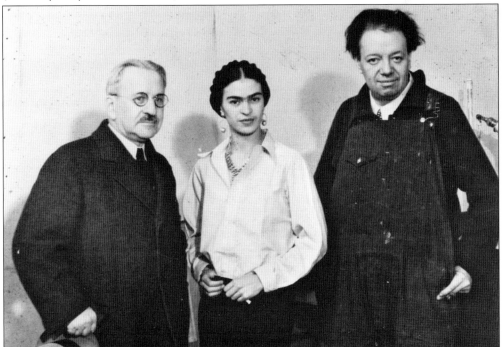

Rivera and Kahlo appreciated the Salmons' hospitality and the fact that they invited them to family gatherings including a baptism in Toledo, Ohio. They were down-to-earth and a friendly couple. As one of many tokens of appreciation, they gave the Salmons this photograph that shows, from left to right, industrial architect Albert Kahn, Frida Kahlo, and Diego Rivera. (Sylvia Salmon Ross.)

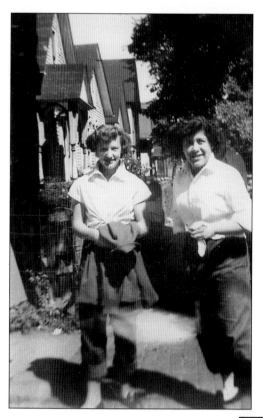

Louise Mendoza (right) and her childhood friend Joanne Rebant are dressed in the trendy clothing of the year 1950. The casual look is rolled-up blue jeans with white socks and loafers and a simple white button-down blouse that was tied in the front. The two of them look like sisters. Their hairstyle was created with pin curls that were made with bobby pins. They are going to some sort of casual social event. (Author's collection.)

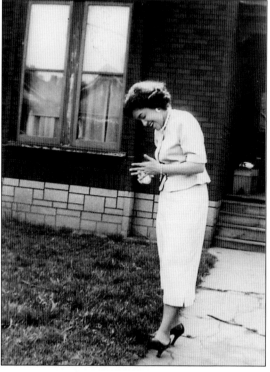

Tina Faustina Mata is waiting to leave for an event. She is elegantly dressed in a suit, solid heels, and the must-have accessories of the day. The house has faux brick siding, which was common in the late 1940s. (Courtesy of Rosa Ybarra.)

This photograph shows some of the prosperity that was found in Detroit. Henry Ybarra stands at the far right with his coworkers just west of downtown Detroit. He was a chef at the Fort Shelby Hotel on West Lafayette Street near Second Avenue. (Courtesy of Rosa Ybarra.)

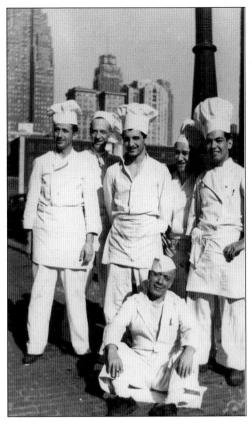

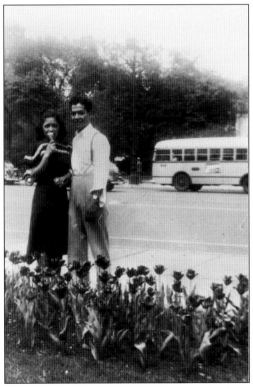

Henry and Carmen Ybarra are enjoying a stroll in the downtown Detroit area, possibly Grand Circus Park, in the late 1940s. (Courtesy of Rosa Ybarra.)

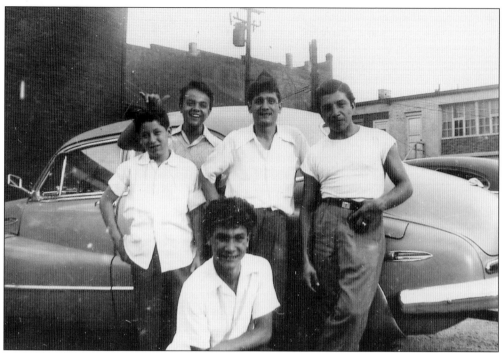

Not everyone initially settled in southwest Detroit. Florencio and Ricardo Perea first lived in the old Italian neighborhood near Eastern Market. In this photograph are, from left to right, (standing) Manuel Mendoza, Florencio Perea, Joe Macucci, and Ricardo Perea; kneeling in front is Joe Litto. (Courtesy of Florencio Perea.)

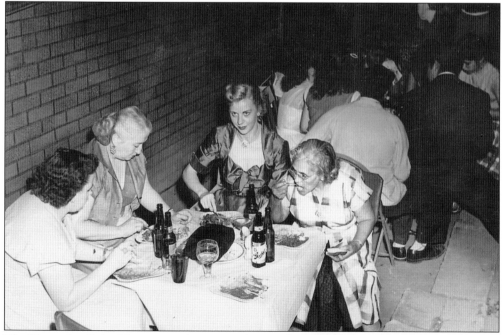

The Ybarra family had frequent gatherings at their enclave. The ladies at this party are enjoying some great homemade dishes that Carmen and Henry prepared. (Courtesy of Rosa Ybarra.)

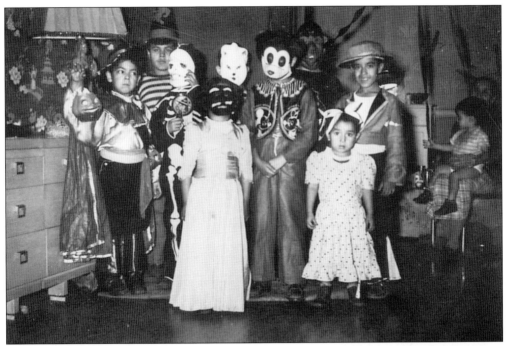

Henry F. Ybarra (far left) is dressed as a swashbuckler and holding a papier-mâché jack-o'-lantern as he poses with his cousins before they head out to do some Halloween trick-or-treating. (Courtesy of Rosa Ybarra.)

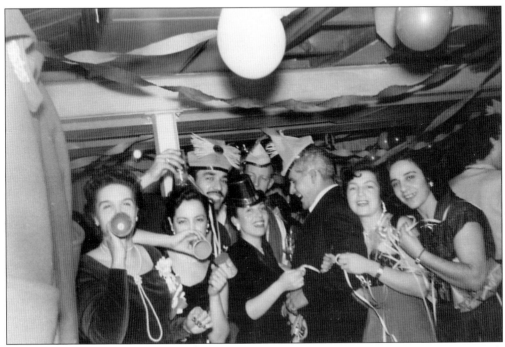

The Ybarra Clan brings in the New Year 1951. It was common to have parties in the basement with lots of decoration, food, and beverages. It was always a good time. (Courtesy of Rosa Ybarra.)

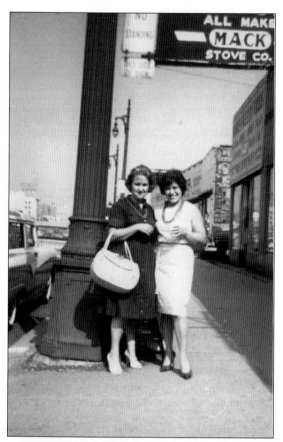

Louise Perea and another childhood friend, Lois Hoeft, pose in front of a social hall on Michigan Avenue and Eighteenth Street before attending a reception. (Courtesy of Florencio Perea.)

This photograph was taken after baby Sharon Matweychek was baptized. She is the author's first cousin. Multicultural marriages were more common in the Midwest than in the Southwest. The author's maternal aunt married Michael Matweychek, who was born in the United States of Ukrainian heritage. The cousins were raised to only consider themselves Americans. That was very common in the 1950s. (Courtesy of Florencio Perea.)

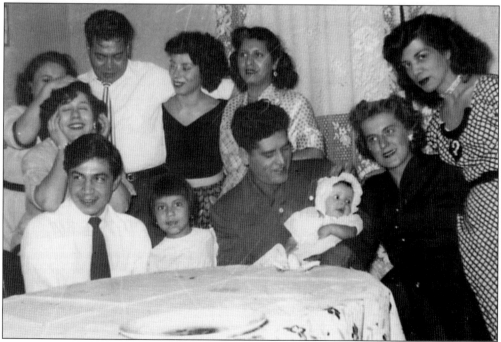

From left to right, Juanita Matweychek, Lillie Alvarez, and Grandma Pearl Matweychek attend the author's Holy Communion party at a social club on Michigan Avenue and Eighteenth Street. These three ladies left an indelible mark on the author. Grandma Pearl taught Juanita how to make perohy. After tasting them, the author had high expectations that all perohy would be just like Grandma Pearl's. Aunt Lillie was an independent workingwoman from the South. She was very sweet to all of her nieces and nephews. She married into the Alvarez clan. Grandma Pearl was the mother-in-law of the author's aunt. She spoke very little English, just like the author's other grandmother, Trinita. At family gatherings, the family always sat them together as if they could understand each other, one speaking Spanish and the other Ukrainian. (Courtesy of Florencio Perea.)

 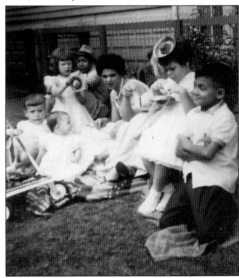

At left, in 1966, birthday boy Felipe Perea enjoys a sip of Oso pop next to his buddy David Villanueva. At right, in 1959, this family served all-American hot dogs and soda pop made at a John Kar bottling plant on West Jefferson Avenue and Dearborn Street at a birthday party in Delray. (Both courtesy of Florencio Perea.)

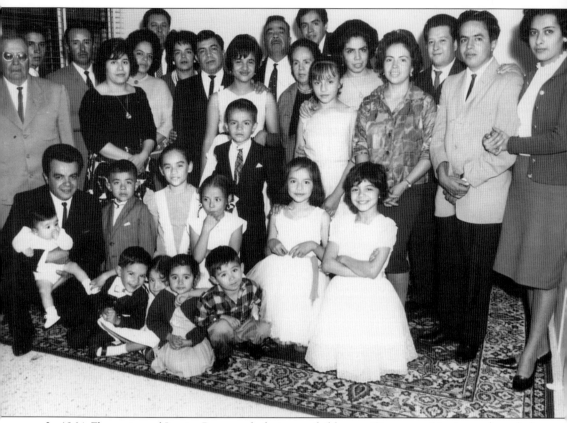

In 1964, Florencio and Louise Perea took their two children to Queretaro, Mexico, to have baby Felipe baptized there. It was the one and only time that the Pereas took an extended Christmas vacation to Mexico. Usually, they would spend their summers in Mexico once the children were on vacation. Since Florencio was the only son not living in Mexico, this is the only complete portrait of the Perea Rodriguez family. (Courtesy of Florencio Perea.)

Florencio Perea poses with Teresa Macucci, the owner of the boardinghouse located on the east side where he first lived when he arrived in Detroit. He remained friends with Macucci and her family until her passing. (Courtesy of Florencio Perea.)

Louise and Manuel Mendoza were born in Detroit. Their parents were from Mexico and spoke very little English. Louise and Manuel spoke very little Spanish because they thought it was so old-fashioned. Yet they knew enough to communicate with their parents, and their father knew enough English to always have a steady job, even during the Depression. (Courtesy of Louise Perea.)

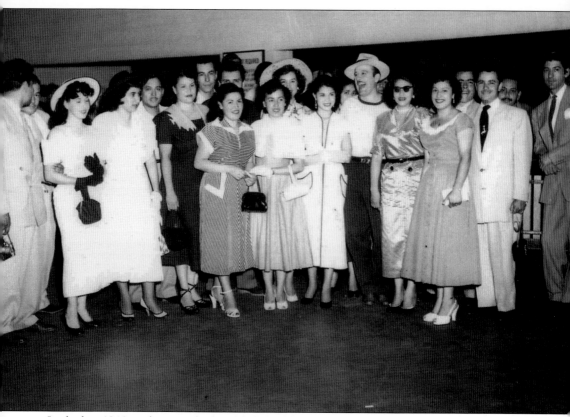

In the late 1940s, a distinguished and fashionable group from the Mexican community welcomed a big star to Detroit. These people met Pedro Infante (right center, in hat) at the Eastern Airlines gate at Willow Run Airport in Ypsilanti, Michigan. The group includes Connie Gutierrez, Raymond Abundis, Beatrice Gonzalez, and many more. (Courtesy of Beatrice Gonzalez.)

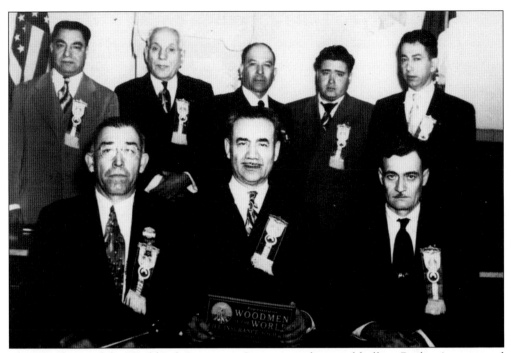

The Woodmen of the World Life Insurance Group owned a social hall on Bagley Avenue, and members organized and hosted Christmas parties for children as well as Mexican patriotic festivities. (Sylvia Salmon Ross.)

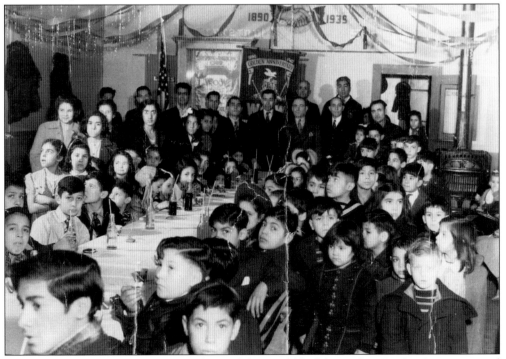

A children's party is held at the Woodmen of the World hall located on Bagley Avenue around 1941. (Sylvia Salmon Ross.)

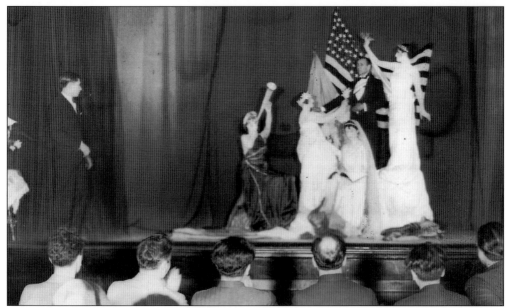

In the 1920s, historically themed pageantry was common. It is not clear if the gentleman surrounded by the women dressed as the Statue of Liberty and images of freedom was celebrating an event in American history or was portraying Mexican president Benito Juarez. This was at Western High School in the mid-1920s. (Sylvia Salmon Ross.)

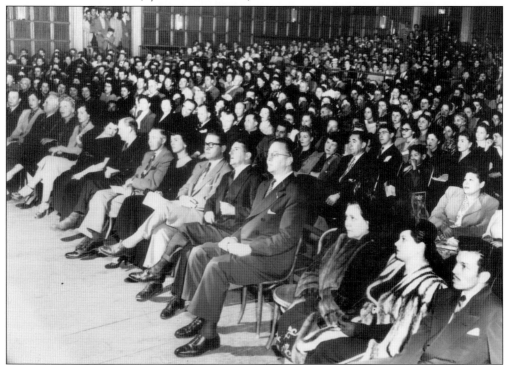

Mexico's Independence Day celebration was always a major holiday. Here is a standing-room-only crowd at Western High School in the mid-1930s. Cass Technical High School in downtown Detroit was another favorite venue to celebrate Mexican independence. (Sylvia Salmon Ross.)

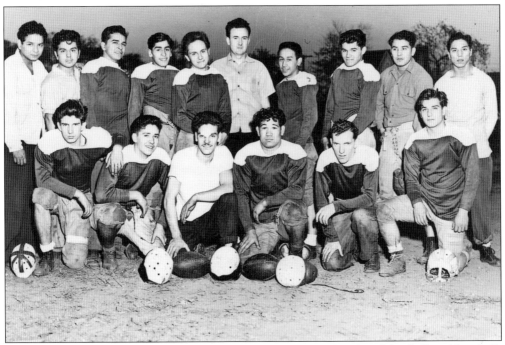

Mexican boys in Detroit were like boys almost everywhere. They loved football and baseball. Here, the Western High School Cowboys pose for school photographer Jim Tafoya. Tafoya went on to work with Tony Spina at the *Detroit Free Press*. (Courtesy of Ray Lozano.)

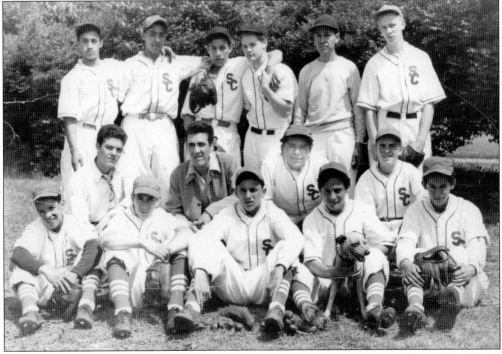

Antonio Lozano (standing second from right) enjoyed coaching the boys in the neighborhood, including players on this baseball team. (Courtesy of Ray Lozano.)

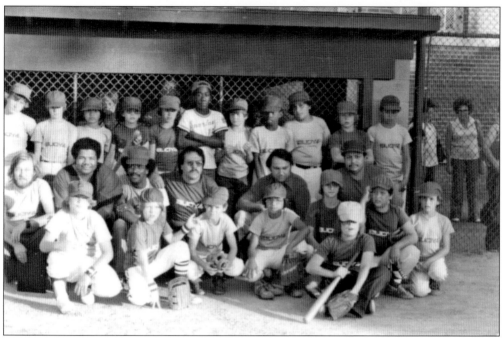

Baseball continues to bring the neighborhood kids together. In 1971, it was common to see diverse teams like this one from Delray, a close-knit neighborhood in southwest Detroit. (Courtesy of Florencio Perea.)

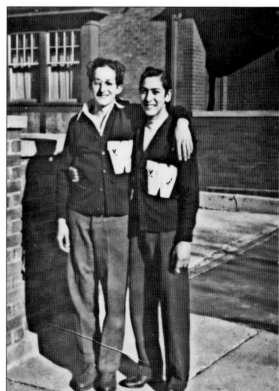

Brothers William (left) and Alfred Lozano were both lettered varsity athletes at Western High School. (Courtesy of Ray Lozano.)

In 1951, Beatrice Gonzalez attended a gala dance at the Veterans Memorial Building in downtown Detroit. Originally from Moroleon, Guanajuato, she moved to Michigan to work. Gonzalez started out working in Imlay City as a farm worker. Then, she moved to Detroit, where she worked at La Paloma market and then at the Teatro Modelo that was located on Michigan Avenue at Twenty-second Street. By 1954, she had saved up enough money to bring her mother and siblings to Detroit. (Courtesy of Beatrice Gonzalez.)

Beatrice Gonzalez enjoyed meeting the celebrities who visited Detroit. There were a few promoters who successfully brought big film stars to the Mexican community. In 1952, Beatrice and her sister Consuelo pose in front of the Theater Modelo on Michigan Avenue at Twenty-second Street with Rene Ruiz, better known as Tun-Tun. (Courtesy of Beatrice Gonzalez.)

This photograph was taken in a popular night club in Mexico City around 1953. Florencio Perea and his bride, Louise Perea (second from the left), are next to his mother, Conchita Rodriguez de Perea, and his sister Socorro Perea. Mambo and rumba orchestras were the rage. Their distinctive sound was imported to Detroit. (Courtesy of Florencio Perea.)

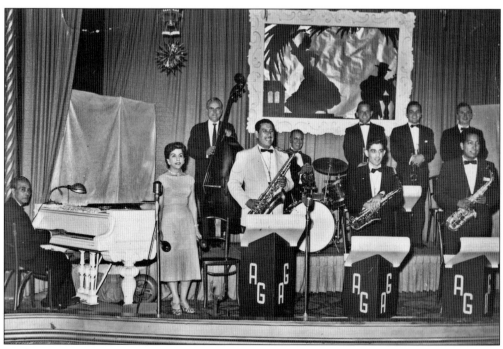

Big band music was very popular in the 1940s. Latin music was performed by big bands in the United States. One local orchestra led by Al Gonzalez had a huge following in the Detroit area. (Courtesy of Sally B. Ramon.)

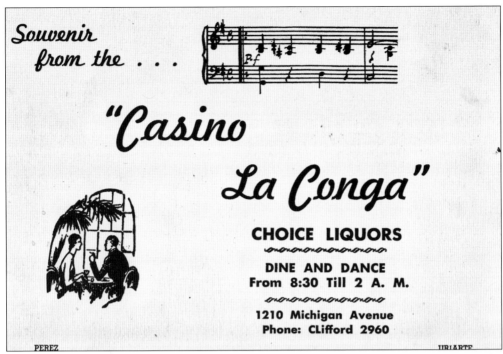

Casino La Conga nightclub had a sophisticated ambiance, akin to Mexico City or New York. The nightclub booked top entertainment and included cigarette girls selling cigars, cigarettes, and candies. Souvenir photographs taken on the premises were available. (Courtesy Rosa Ybarra.)

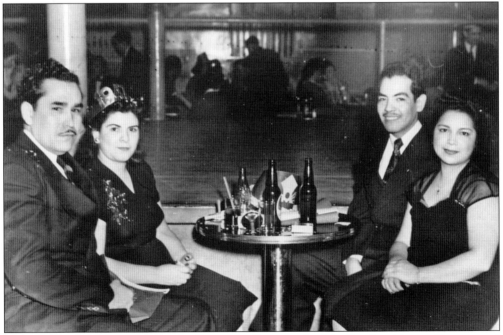

This photo was taken in 1947 at the Casino La Conga nightclub. On the right are Carmen and Henry Ybarra. (Courtesy of Rosa Ybarra.)

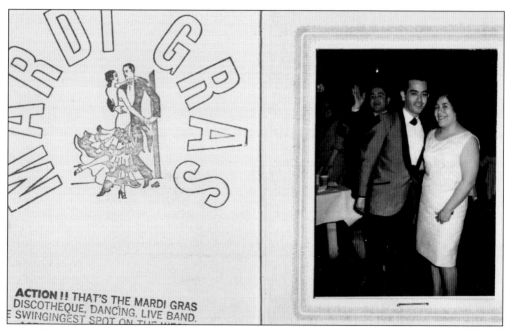

Many big-name musicians came to Detroit, including Luis Alcaraz, seen here with Louise Perea in the mid-1960s at the Mardi Gras on Livernois Avenue at Fullerton Street. (Courtesy of Florencio Perea.)

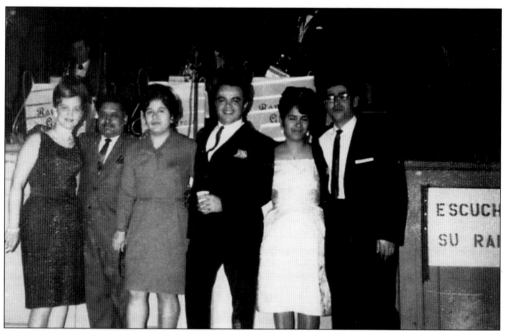

Hispanos Unidos hall was a popular spot in southwest Detroit that hosted many big bands, including Raul Garcia's Orchestra. Here, from left to right, are Marie and Dave Villanueva, Louise and Florencio Perea, and Rita and Hector Gonzalez in the late 1960s. The big-band sound soon faded, and dances held at Hispanos Unidos were less frequent as new suburban venues grew in popularity. (Courtesy of Florencio Perea.)

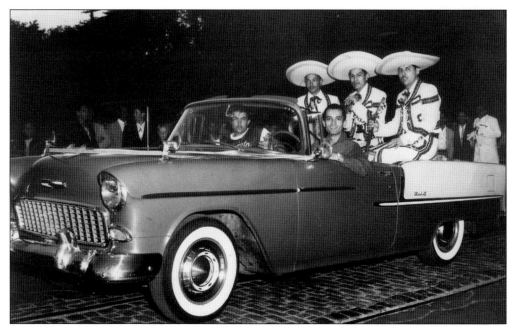

The popular Trio Reyna participated in the Mexican Independence Parade in 1957. The parade route was down Michigan Avenue. Angel Cotto, Vicente "Truko" Gonzalez, and Daniel Gonzalez sit on the back of a cherry-red Chevrolet Bel Air. (Courtesy of Sally B. Ramon.)

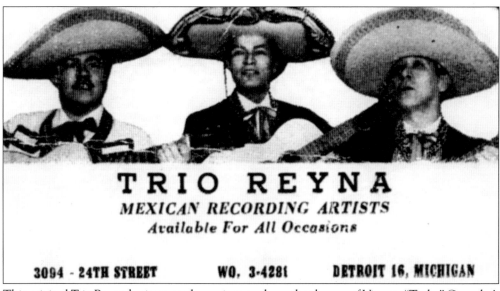

This original Trio Reyna business card was given to the author by one of Vicente "Truko" Gonzalez's daughters, Raquel. An original card, it has no area code or elaborate zip code. Pictured on the card are, from left to right, Angel Cotto, "Truko," and brother Daniel Gonzalez. Interestingly, Truko's daughter and the author were friends in high school but never discussed his work. Raquel inherited her father's vocal talent. (Courtesy of Raquel Palady.)

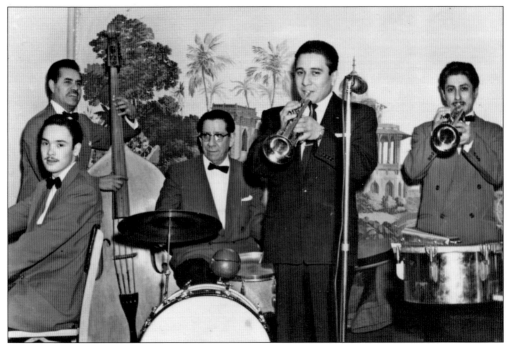

One of the best-known musical groups in Detroit was Panchito and Orchestra. This photograph is from the mid-1940s. Francisco Lozano and his orchestra were in great demand because of the popularity of the Latin sound. He was also a dedicated public school teacher and later became the principal at Webster Elementary School in Mexicantown. (Courtesy of Sylvia Salmon Ross.)

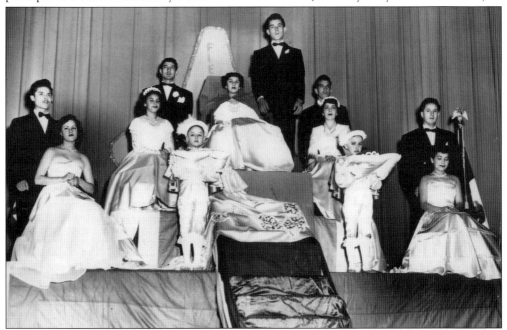

For Mexico's Independence Day on September 15, 1949, the coronation ball selected Sylvia Ross to reign as queen of the festivities. She is photographed here with her entire court. (Courtesy of Sylvia Salmon Ross.)

This plaque is located at the Wyandotte VFW Post 1136. New residents and citizens stepped up to serve in the US military forces. (Courtesy of Pablo Savala.)

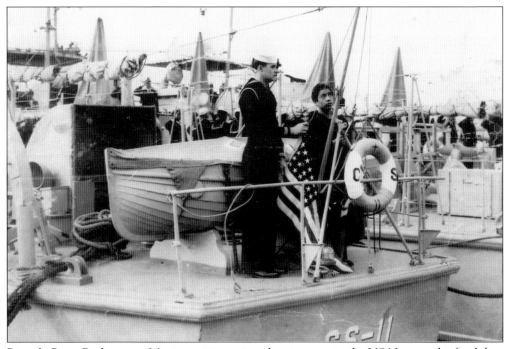

Ricardo Perea Rodriguez, a Mexican citizen, signed up to serve in the US Navy in the final days of World War II. (Courtesy of Ricardo Perea Gonzalez.)

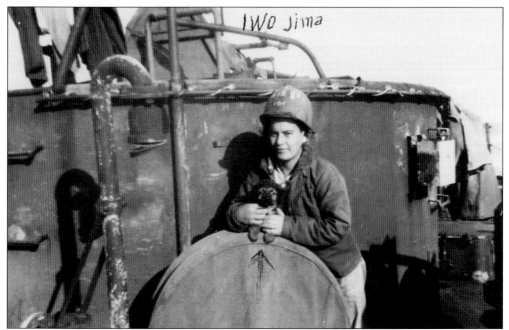

Pablo Savala was a very young sailor during World War II. Here, he is holding a little dog. Savala was only 17 years old when he served on the USS *PCE-877*. The ship was preparing for the invasion of Japan when the atomic bombs were dropped. The war was over, and the *PCE-877* became part of the occupation. Earlier, Pablo had witnessed the raising of the US flag on Iwo Jima from the deck of *PCE-877*. Later, he saw the battleship *Missouri* in Tokyo Bay. (Courtesy of Pablo Savala.)

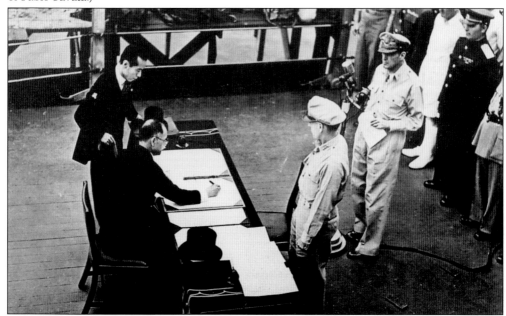

On September 2, 1945, the USS *Missouri* secured its place in history as the site of Japan's unconditional surrender to the Allied forces, ending World War II. This photograph was taken by an unknown sailor. Pablo Savala bought this copy for 50¢. (Courtesy of Pablo Savala.)

On military leave, Alex Alfaro arrives at the Grand Central train station at West Vernor Highway at Fourteenth Street, just a few blocks away from his parents' home on Bagley Avenue. (Courtesy of Aurelia Alfaro Savala.)

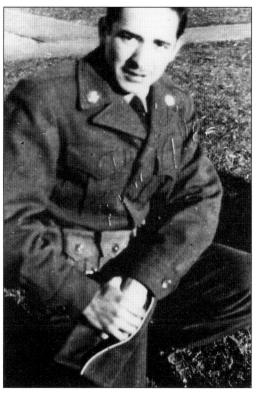

Vincent Alvarez enlisted in the US Army Air Forces during World War II. He had his photograph taken at Camp Anderson. Mexican American men and women have served in the US armed forces since the Civil War. (Courtesy of Lopez-Ramirez family.)

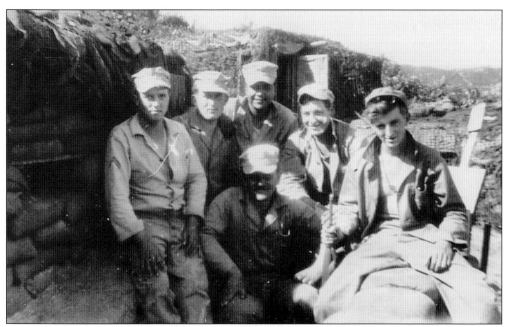

David Alonzo, born and raised in Corktown-Detroit, proudly enlisted in the US Marines. Here, he is third from the left. He was a Korean War combat veteran. (Courtesy of Alonzo family.)

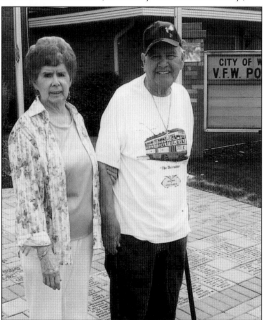

At left, SSgt. Albert Rodriguez is a veteran of the 2nd Battalion 23rd Marine Regiment 4th Marine Division as well as the author's brother-in-law. The unit supported the 1st Marine Division crossing "the line of departure" into Iraq on March 20, 2003. The ranks of the 2/23 included many Mexican immigrants and first generation Mexican Americans. Rancheras blared from their Humvees as they charged up the east bank of the Tigris River. At right, Pablo Savala and his devoted wife Aurelia continue to participate in veteran events at VFW Post 1136 in Wyandotte, Michigan. (Left, courtesy of Maximo Rodriguez; right, courtesy of Pablo Savala.)

Jorge Tapia (center) was one of the most sought-after mechanics, living a few blocks from Ste. Anne's Church. Over the years many engineers and designers have sought his input. Tapia moved to Texas, and rumor has it that he is doing what he loves to do, fishing. (Courtesy of Florencio Perea.)

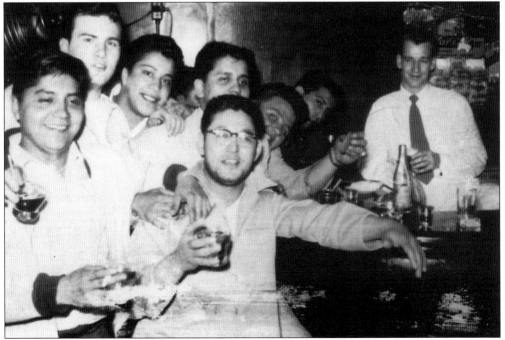

Corktown, Mexicantown, and southwest Detroit include a good number of bars and taverns. Here, at a neighborhood bar in Corktown, Dave Alonzo (far left) and his buddies are having a grand time. (Courtesy of Alonzo family.).

The grounds crew at Detroit's Tiger Stadium, located on the corner of Michigan and Trumbull Avenues, poses here. Most of them lived within walking distance. Dave Alonzo (center) loved his job. (Courtesy of Alonzo family.)

Felipe Perea (center, with glasses) and his grandfather Arcadio Mendoza are enjoying a baseball game at Tiger Stadium. Arcadio was visiting from Michoacan, Mexico. He traveled throughout the United States, finally settling in Detroit. He was a gandy dancer, or traquero, doing the hard work of laying railroad tracks. Later, he worked in the meatpacking district—even throughout the Depression—up to his retirement. In his later years, he moved back to his hometown in Michoacan, where he had a little farm, and remarried. (Courtesy of Florencio Perea.)

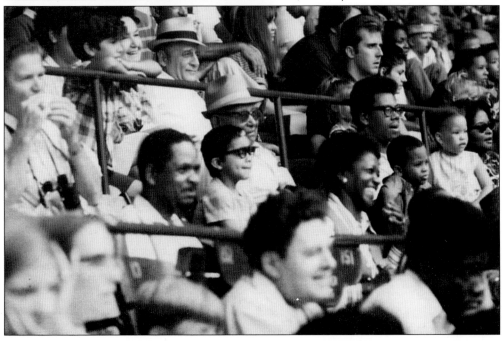

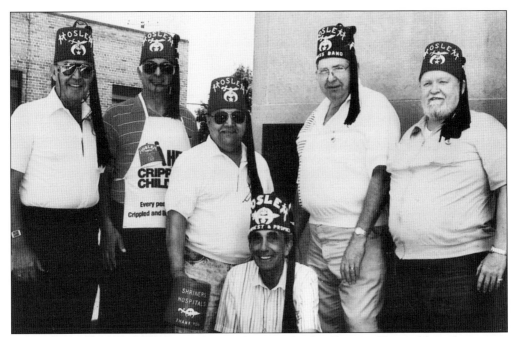

Dave Alonzo (third from left) actively raised money for the Shriners Hospital by volunteering for the annual Shrine Circus at the Michigan State Fairgrounds on Woodward Avenue at 8 Mile Road. (Courtesy of Alonzo family.)

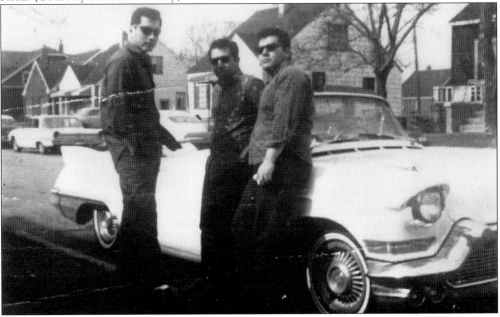

The Ramirez brothers posing in front of their Cadillac were first-generation Mexican Americans. From left to right, Rick, Donald, and Paul were raised in a generation that did not encourage cultural identity. They were skilled tradesmen in the automotive industry, into doo-wop music, and considered by many to be just plain cool. They lived in a rambling house just west of Woodmere Cemetery and behind the Dix masjid, Michigan's oldest mosque. Growing up in southwest Detroit and the south end of Dearborn, their youth was richly diverse. (Courtesy of Donald Ramirez.)

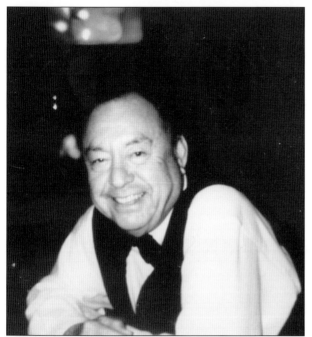

This is a photograph of Jose Reyes. He was the head bartender at the London Chop House for 40 years. On July 26, 2009, someone named Dydan wrote: "His name was Jose Reyes and he made the best damn margaritas in the world. He had a secret recipe that he never shared with anyone. He invented the hummer and was responsible for giving a very young Barbra Streisand something to help her hoarse and sore throat on her first visit to Detroit to perform. His backyard pool parties were legendary—complete with mariachi bands! He was one hell of a man and the Chop House would not have been the hip place it was in its heyday without Jose's unique presence." (Courtesy of Laura Reyes-Kopack.)

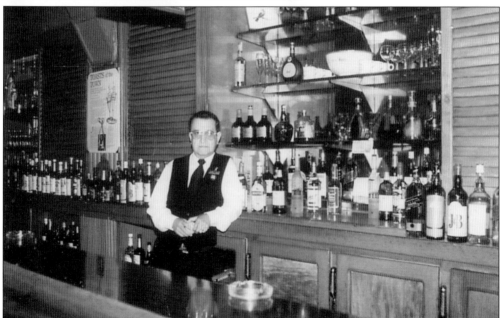

Carlos Alvarez came to Detroit from San Luis Potosi intent on just staying for a short period of time. He met Henry Ybarra, who asked him if he needed work. Carlos replied that he wanted something temporary. In the late 1950s and early 1960s, just a handshake was enough to get a job. That was the case with Carlos and his temporary work, lasting 39 years at the Caucus Club owned by the late Les Gruber. The London Chop House and the Caucus Club were the preferred watering holes of the automotive executives, advertising agents, and the jet set. Carlos refined the signature drinks at the Caucus Club. The London Chop had an exceptional staff, almost all of whom were Mexican and Latino immigrants. (Courtesy of Carlos Alvarez.)

Three

PROGRESS

Just west of Corktown on Michigan Avenue there was a bustling area. It included Western Market, the counterpart of Eastern Market, the Azteca movie theater, restaurants, a record shop that sold the latest Mexican music, and Perea Meats, the first Mexican butcher shop in Detroit. The bustle expanded to Bagley Avenue. La Bagley was and is the definitive heart and soul of what is now Mexicantown. There was another expansion onto West Vernor Highway, an important corridor that runs all the way into Dearborn.

Change came in the late 1960s. A large part of the neighborhood was lost to the construction of the I-75 freeway. It was almost devastating. Luckily, southwest Detroit was not exclusively commercial, industrial, or residential. Many businesses stayed and adapted. Longtime residents did, too. Life had been good for anyone with a job at the Ford Rouge plant in Dearborn or at the three General Motors plants in southwest Detroit. Back then, workers could walk to their jobs. The Baker Street trolley and, later, the Baker bus line ran from downtown all the way to the Ford Rouge plant. By the late 1980s, the General Motors plants had closed.

For more than 40 years, Mexicantown has dealt with I-75 bisecting the community. Its most obvious impact was on Bagley Avenue. East of the freeway, it felt like an island. Mexican Village, the oldest Mexican restaurant in Detroit, survived. Algo Especial grew over 30 years in the same block. The Honeybee (La Colmena) market has also thrived.

Bagley Avenue west of the freeway is a solid block of businesses. It is a healthy mix of old and new from the first tortilla factory, La Michoacana, to Taqueria Lupita, one of the first of the taquerias in southwest Detroit.

Over the years, local businesses were assisted by the Southwest Detroit Business Association and, later, Mexicantown Community Development Corporation. Programming was developed, providing training, facade improvement, and business development. These initiatives succeeded in expanding the customer base and branding the district.

Today, Mexicantown is a destination site because of the great attention to customer service at its businesses. It is a shining example of the results of resilience and hard work. It is the only part of Detroit that grew in the 1990s and holds its own today. Serious issues—air quality, safety, and overall basic city services—need to be addressed, but this does not seem to deter people from living and working there.

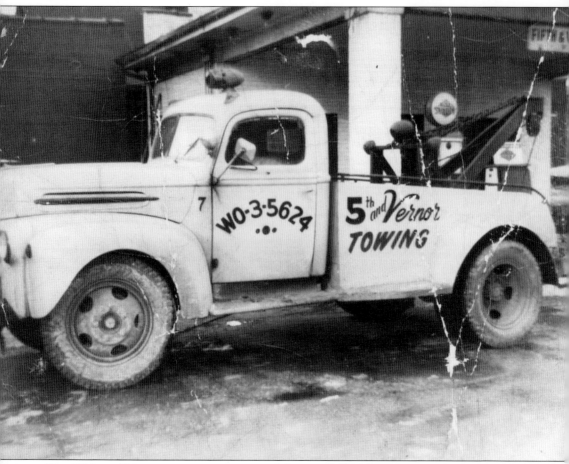

The Fifth and Vernor towing company and Sunoco full-service gas station was one of many enterprises that were wiped out by the construction of I-75. Affected businesses had to decide to either relocate within city limits or move out. Unfortunately, many moved out or just closed. (Courtesy of Rosa Ybarra.)

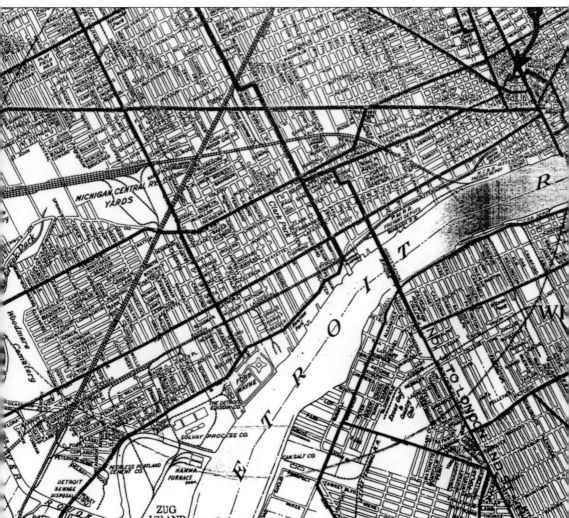

Detroit was a very different place prior to the freeways that would dissect its southwest area. For many years, the residents really did not believe that the freeways would actually be built and did not give any serious thought to how it would impact their neighborhoods. In addition to the freeways being built, there was the oil embargo in the 1970s. The auto plants in southwest Detroit began to shut their doors. Before the freeways, there was an efficient public transportation system. A person could get on a bus from any point around the city and ride into downtown. The best shopping area was on Woodward Avenue between Grand Circus Park and Fort Street. (Courtesy of Benson Ford Research Center.)

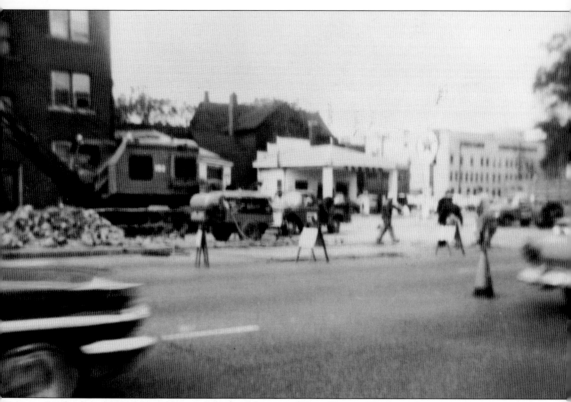

In the late 1950s, demolition of the buildings on West Vernor Highway began in preparation for I-75. (Courtesy of Rosa Ybarra.)

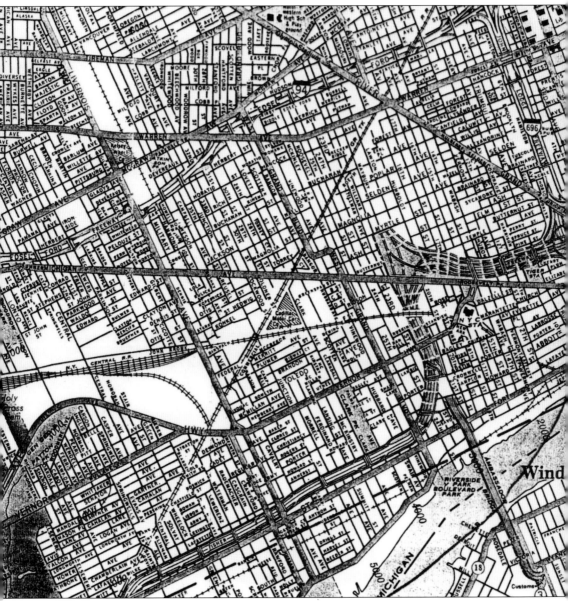

The road map of "Detroit & Southeast Michigan, 1967" shows how the mostly residential parts of southwest Detroit and Corktown were virtually wiped out and replaced with freeways. After 40-plus years, neighborhoods are still affected. Residents and nonprofit organizations continue to work on rebuilding the commercial districts and housing. (Courtesy of Benson Ford Research Center.)

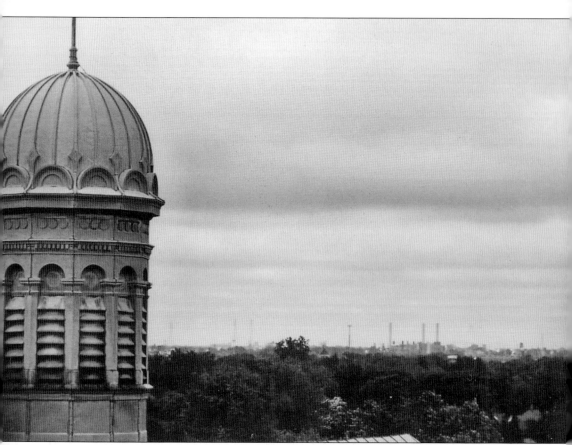

This is a contemporary view from the bell tower of Holy Redeemer Catholic Church located at West Vernor Highway and Junction Avenue. (Author's collection.)

An example of the mix of commercial buildings, residences, and churches in proximity that make for a vibrant neighborhood is seen here. This particular view shows West Vernor Highway near Campbell Street. (Author's collection.)

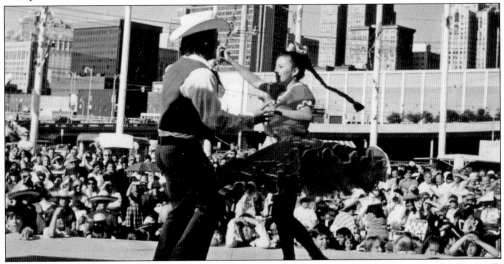

This couple performed at the 1976 Mexican Festival on Detroit's Riverfront, just west of Cobo Hall. Change in Detroit was not limited to building freeways. After the 1967 riots, city leaders wanted to establish a common ground, or at the least a mutual understanding, between the different cultures that made Detroit special. Edward L. Gajec, Carmen Cortina, Luci Arellano, and Fr. Clement Kern met with the Mexican Patriotic Committee, Maria Alcala, Alfonso Gonzalez, and several business owners to organize the first Mexican riverfront festival on the Detroit River next to the Veterans Memorial Building. Downtown Detroit was about to begin a renaissance of its own, with Hart Plaza being built next to Ford Auditorium on the river. Henry Ford II would lead the building of the Renaissance Center next to the Detroit-Windsor Tunnel. Eventually, the venue for all ethnic and music festivals would be Hart Plaza. (Courtesy of Dr. Lucile C. Gajec.)

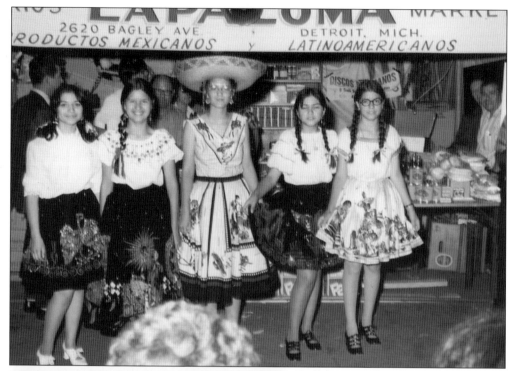

La Paloma market was one of the first Mexican specialty stores to open on Bagley Avenue. The market was adjacent to Mexican Village Restaurant. Eventually, the market's owners would sell their part of the building to the owners of the restaurant. (Courtesy of Dr. Lucile C. Gajec.)

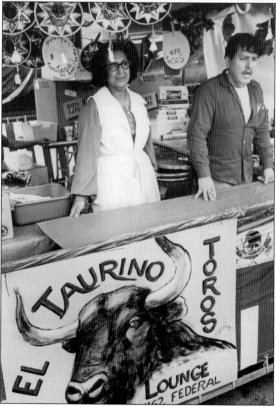

Most of the Mexican restaurants and bars had a presence at the festivals and sometimes had live entertainment at their booths. El Taurino Lounge was one of them. (Courtesy of Dr. Lucile C. Gajec.)

This young, unidentified lady embodies the carefree days at the Mexican ethnic festivals of the 1970s. Her Ray-Ban sunglasses and classic T-shirt with "me siento . . . Pretty Good Fine," popularized by DJ Julian Suarez on a local radio program in Detroit, are timeless. (Courtesy of Dr. Lucile C. Gajec.)

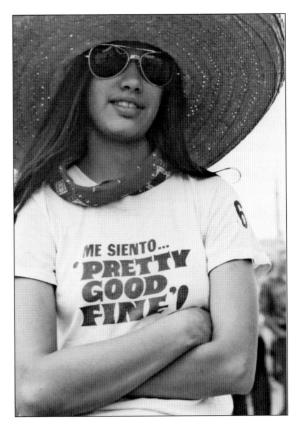

The Mexican ethnic festival was one of the four most popular festivals. For the Mexican community, it was a family reunion. Attendees were likely to see their old neighbors, childhood friends, and classmates. It featured folkloric dance troupes and live music. The Corktown Dancers were directed by Carmen Cortina. They danced to music from the Mexican Revolution of 1910. (Courtesy of Dr. Lucile C. Gajec.)

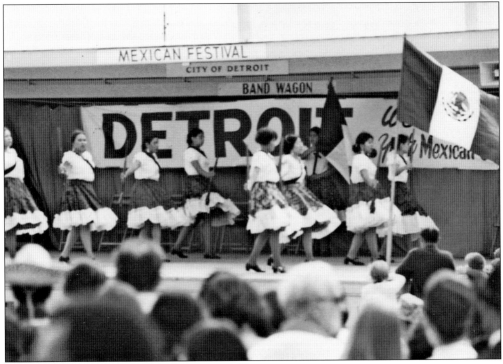

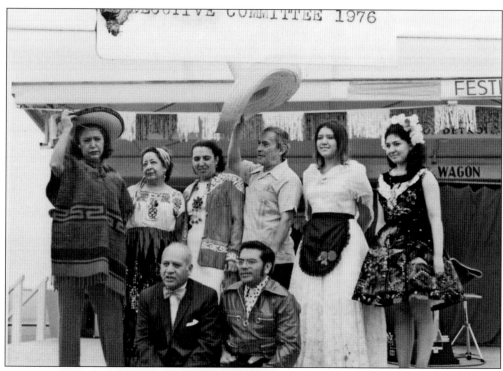

The 1976 Mexican Festival was organized by an executive committee that includes, from left to right, (sitting) Anthony Alvarez and Salvador Rojas; (standing) Dr. Lucile C. Gajec, Amparo Alvarez, Maria Guerra, Tony Guerra, Rachel Arellano, and Blanca Sosa. (Courtesy of Dr. Lucile C. Gajec.)

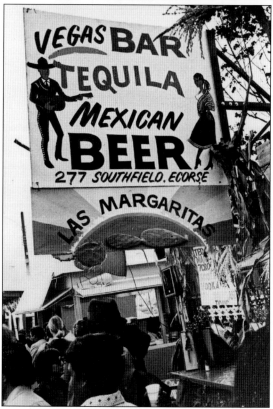

The Mexican-owned businesses were not limited to Detroit. Vegas bar opened in Ecorse, Michigan. With live music every weekend, it was very popular. At the Mexican riverfront festival, Vegas served margaritas. (Courtesy of Dr. Lucile C. Gajec.)

Four

FAITH

The Catholic Church has always been an essential partner to Detroit's Mexican community. Adversity and challenges require faith. Moving to a cold, northern city like Detroit took a leap of faith. The first Mexican church was Our Lady of Guadalupe on Kirby and Roosevelt Streets. It was a bad location. Established to provide an alternative to St. Mary's in Greektown, Our Lady of Guadalupe Church saw a huge drop in attendance due to the location and the repatriation in the early 1930s, and it was closed down.

The author's grandmother moved her family to the eastside of Detroit. Other families did the same. They went to neighborhoods near Eastern Market to survive the crisis. It worked; after several years, they returned to Mexicantown.

In the early 1940s, Most Holy Trinity Church, led by the charismatic and generous Fr. Clement Kern, welcomed the Mexican community. Mexicans also worshiped at St. Vincent and St. Boniface. Ste. Anne's Church's present location (its sixth) at Lafayette and St. Anne Streets was completed in 1887. It was founded in 1701, one day after Antoine Cadillac founded Detroit. In the early 1940s, Mexicans began worshiping there.

Holy Redeemer, located further west at West Vernor Highway and Junction Avenue, takes up almost four blocks. It includes the church, rectory, convent, elementary school, high school, and a three-story cultural building with a theater. It usually had 200 students enrolled in each grade. Latino students were the exception. Even in the late 1960s, most students were of European descent.

The community held onto its religious and family traditions. Baptisms, first Communions, confirmations, and Quincieneras were all major celebrations. Traditional weddings became more common with mariachis performing during mass.

Now, because of constant growth, all Catholic churches in southwest Detroit have increased their number of Spanish-language masses. The feast day of Our Lady of Guadalupe is celebrated in local churches and in the surrounding suburbs. Imagery of Our Lady of Guadalupe is ubiquitous. The Guadalupanas were a female group of devotees. Every member proudly wore her medal on a multistriped ribbon at ceremonies on December 12, her feast day.

The Archdiocese of Detroit closed Holy Redeemer High School in 2005. But the leadership at Holy Redeemer reorganized and worked out a solution. As a result, Cristo Rey High School opened in Holy Redeemer's former building in 2008.

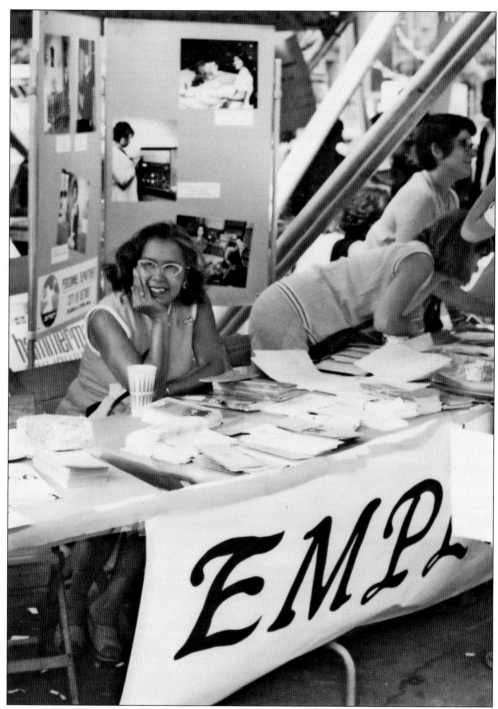

In 1976, Luci Arellano not only worked on the organizing committee for the Mexican riverfront festival, but she also staffed the Michigan Employment Security Commission booth. She was job developer at MESC. Later she obtained a master's degree and a PhD. She was a local historian. Arellano eventually married Edward L. Gajec and enjoyed spending time with her daughter, Rachel, and her grandchildren. (Courtesy of Dr. Lucile C. Gajec.)

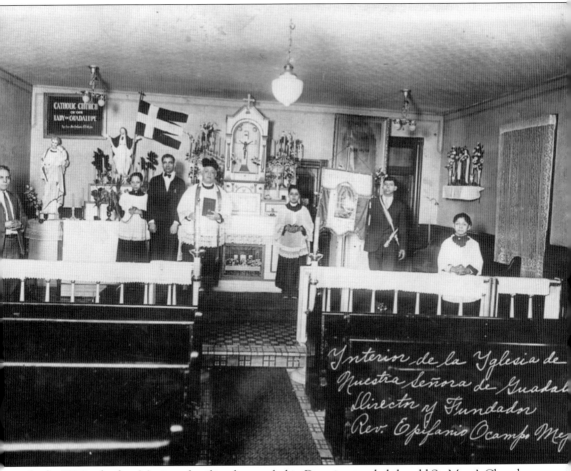

In the 1920s, the first Mexican families that settled in Detroit attended the old St. Mary's Church in Greektown. The newcomers were assigned to a room in the school. They were first led by Fr. Jose Alanis, a priest exiled from Monterrey by the postrevolutionary Mexican government. Around 1923, the Mexicans were no longer welcome at St. Mary's. Fr. Alanis and Fr. John B. Mijares, a Jesuit, decided to build their own church. In 1923, Our Lady of Guadalupe was built at Kirby and Roosevelt Streets but closed its doors 13 years later, mostly due to a poor location and weak pastoral leadership. (Courtesy of Ray Lozano.)

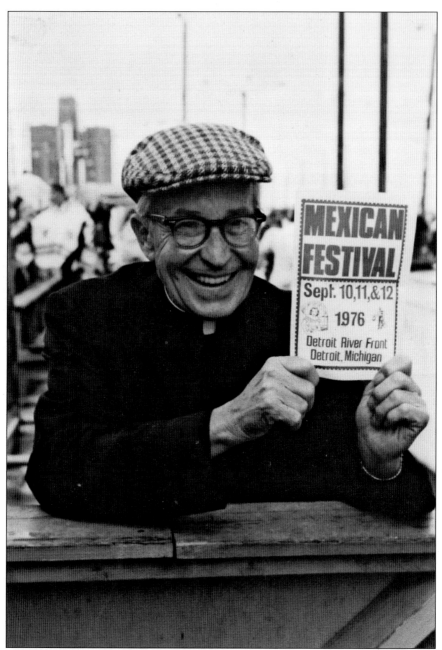

Fr. Clement Kern poses with a copy of the 1976 Mexican Festival program. This image captures his warmth and commitment to the Mexican community. In 1943, Father Kern was assigned to Most Holy Trinity parish. He was more than a familiar pastor. He helped build and organize Detroit's Mexican community. Kern valued and respected cultural and language diversity. He learned Spanish and spent the rest of his life serving the Latino community. Kern also organized efforts to help the indigent and homeless. Through his influence or direct involvement, several organizations—including LA SED (Latin American for Social and Economic Development), the Guadalupanas, HASTA, and the Puerto Rican Club of Detroit—were established. (Courtesy of Dr. Lucile C. Gajec.)

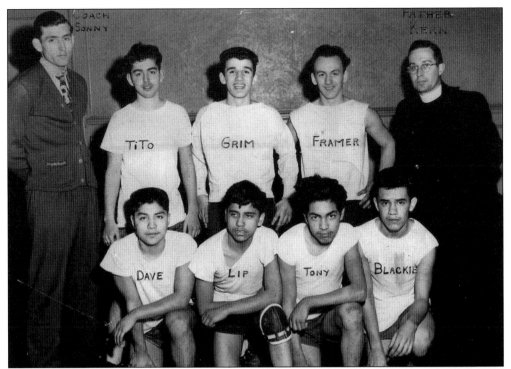

In 1947, Fr. Clement Kern organized programs to keep his students active and instill in them the value of teamwork. The Catholic Youth Organization had a basketball league, and Most Holy Trinity participated. Kneeling in the front row at left is Dave Alonzo, who spent most of his life in Corktown. (Courtesy of Alonzo family.)

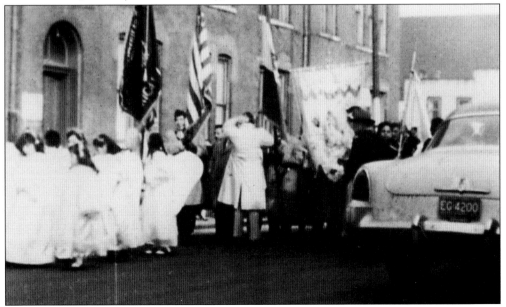

In 1951, the Guadalupanas (devotees to Our Lady of Guadalupe) are preparing to celebrate her feast day on December 12. It appears to have been a mild winter, without snow, as they march past Most Holy Trinity Elementary School. (Courtesy of Rosa Ybarra.)

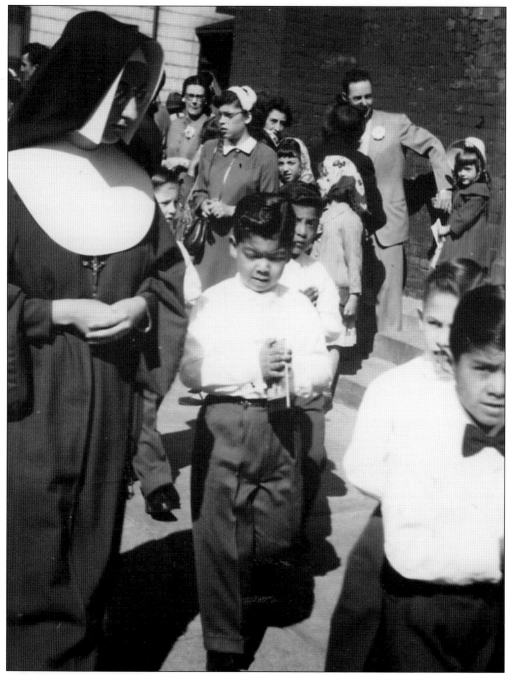
About to make his first Holy Communion, Henry J. Ybarra is walking with one of the Dominican nuns who taught at the school. (Courtesy of Rosa Ybarra.)

In 1970, the interior of Holy Trinity Church is decorated for a Quinceniera. A young girl's 15th birthday is an important rite of passage in the Mexican tradition. The custom was brought to Detroit, and traditional families still have large celebrations for their daughters. (Courtesy of Dr. Lucile C. Gajec.)

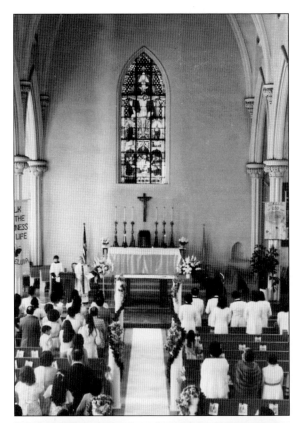

In the late 1960s, some of the families decided to create a debutante ball to collectively celebrate the 15th birthdays of their daughters. (Courtesy of Dr. Lucile C. Gajec.)

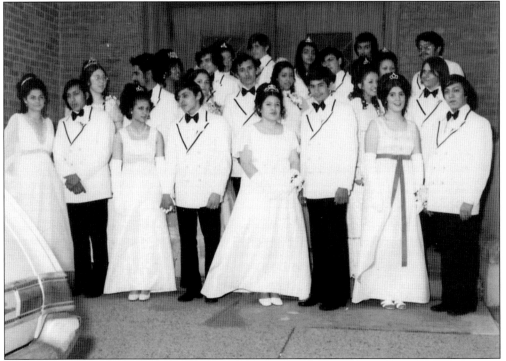

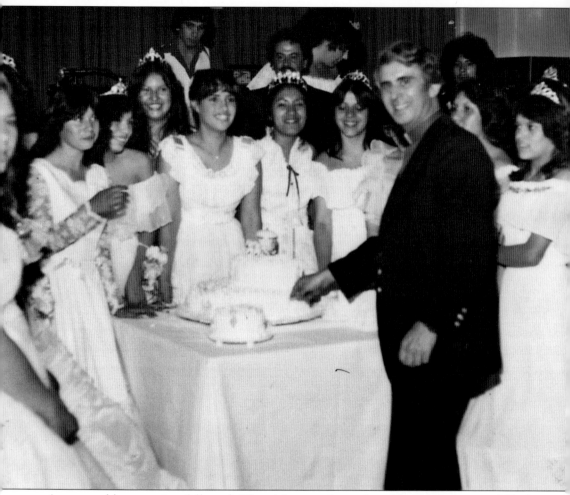

A memorable reception followed. The girls were dressed up like princesses, and Fr. Jay Samonie, co-pastor of Holy Trinity, was there to help them slice the cake. (Courtesy of Dr. Lucile C. Gajec).

No summer would be complete without Holy Trinity's annual excursion to Bob-Lo Island, as noted on the poster attached to the side of the car. Edward Gajec drove in the Cinco de Mayo parade with Rachel Arellano in the front passenger seat and the Solis sisters in the back seat. (Courtesy of Dr. Lucile C. Gajec.)

Four cousins—Paula Lally, Felipe Perea, Patricia Lally, and Alfred Alvarez—are enjoying themselves on one of the rides on Bob-Lo Island. The only way to get there was by boat. It was a slow, leisurely ride from the downtown Detroit dock to the island, which had live music, souvenir shops, and snack bars. It was a summer highlight for many. (Courtesy of Florencio Perea.)

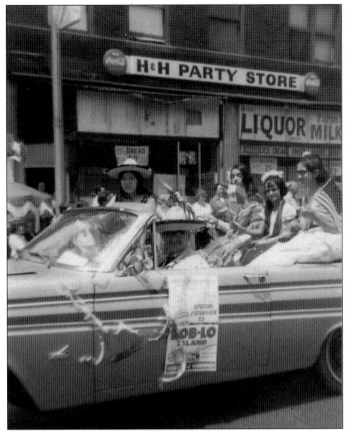

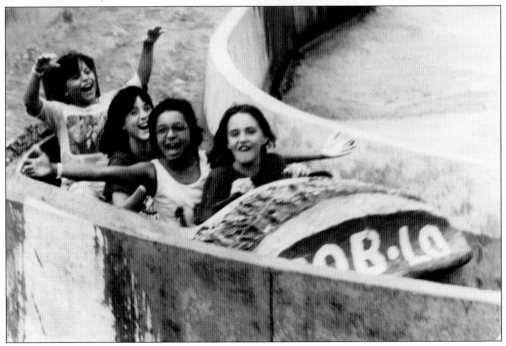

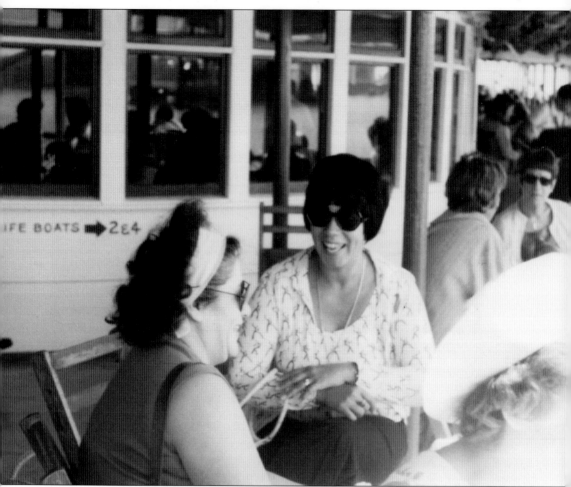
Adults favored the third level on the Bob-Lo boats—especially when returning home. The second level had live music and a huge dance floor. The third level had a bar, and parents could unwind with a few cocktails. Louise Perea (left) and sister Hope Lally are seen here relaxing on the third level. (Courtesy of Florencio Perea.)

Ste. Anne de Detroit Catholic Church is the oldest parish in Detroit, founded one day after the city in 1701. It has been home to many Mexican parishioners since the 1940s. Every Sunday, Spanish-language mass at Catholic churches in Mexicantown is usually standing room only. The Mexican community—especially its new arrivals—has been the lifeblood of the archdiocese as it struggles to keep its churches and schools open. (Author's collection.)

In 1953, Aurelia Alfaro and her wedding party pose in front of her family's duplex at the corner of Bagley Avenue and Eighteenth Street. (Courtesy of Aurelia Alfaro Savala.)

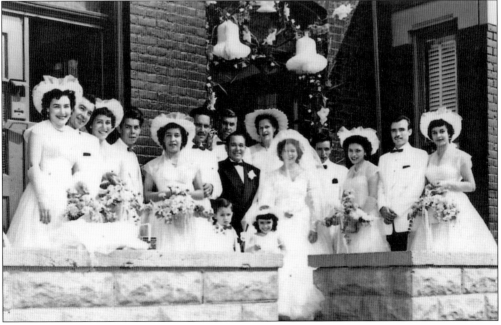

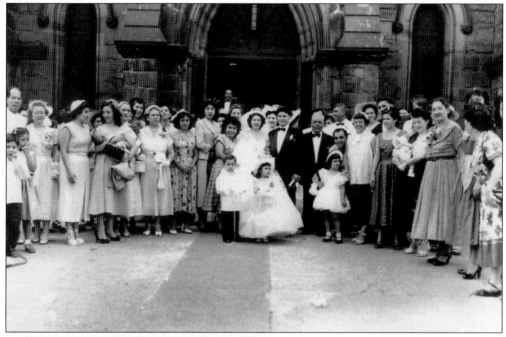

This wedding couple, Aurelia and Pablo Savala, posed with family and friends before heading off for a traditional wedding breakfast. Notice all of the ladies are dressed up in daywear. They will wear cocktail dresses to the evening reception. That was common in the 1940s and 1950s. (Courtesy of Aurelia Alfaro Savala.)

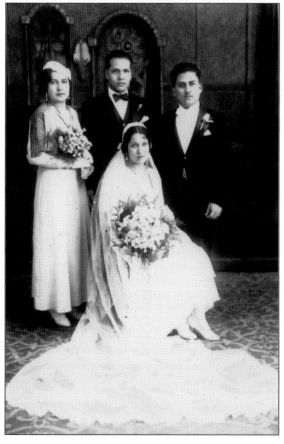

This wedding couple and their relatives had an official studio portrait taken to mark the occasion. This photograph was taken in the United States during the mid-1920s. (Courtesy of Ray Lozano.)

This wedding portrait of Daniel Rodriguez and Genoveva Esparragoza was taken in Puebla, Puebla, on January 7, 1921. Both bride and groom appear subdued and underdressed. Notice that the bride is not wearing a traditional wedding dress. It could very well be that the inevitable church-versus-state war was quietly developing. (Courtesy of Maximo Rodriguez.)

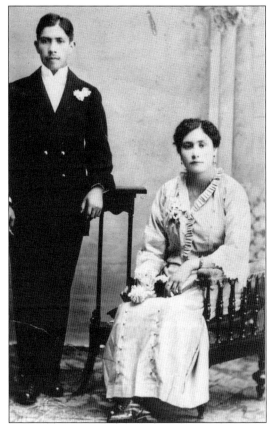

Most Holy Redeemer Catholic Church is located on the corner of Junction Avenue and West Vernor Highway in southwest Detroit. The existing church has been an anchor for the surrounding neighborhood since 1921. The original church was built in 1850 in the same location. Over the years, Most Holy Redeemer has served German, Irish, Polish, and now Mexican immigrants. The church, elementary school, convent, high school, auditorium, rectory, and gardens take up almost one entire city block. (Author's collection.)

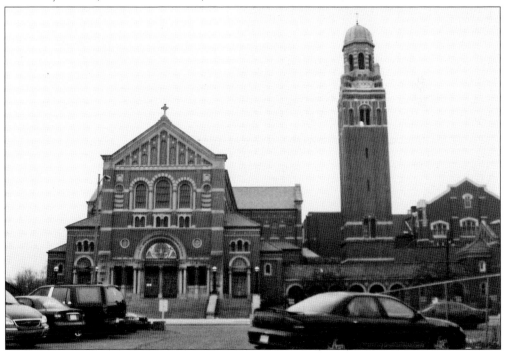

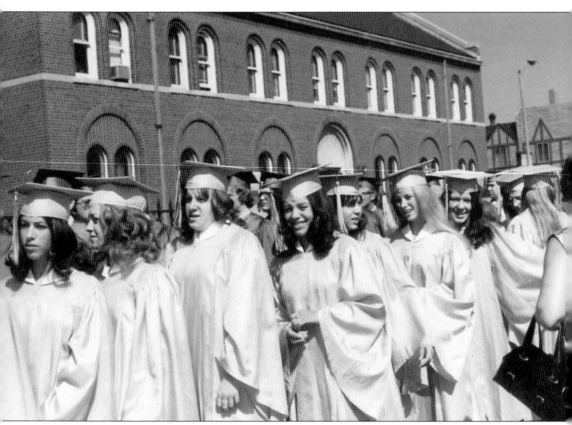

In the late 1960s, the archdiocese began to consolidate the high schools as it closed the smaller schools. As a result, Holy Redeemer's enrollment substantially increased and peaked in 1970–1973, when 1,200 students were attending Holy Redeemer High School, and the senior class was about 350 strong. (Author's collection.)

Five

SOCIAL ORGANIZATIONS

In the late 1920s, auto worker Ignacio Vasquez, a product of the Mexican "normal" teacher's schools, opened a community school for newly arrived immigrants. It failed, but several social/civic organizations were created in the 1920s and 1930s. Included among these were Cruz Azul, Mexican Catholic Society, Latin American Club, Circulo Mutualista Mexicano, Anahuac, Obreros Unidos Mexicanos, Sociedad Emiliano Carranza, Chapultepec, Chihuahenses Unidos, Padres de Familias, Damas Catolicas, Liga de Obreros y Campesinos, Caballeros Catolicos, and Sociedad Guadalupana. The oldest civic organization is Comite Patriotico Mexicano. It organized the annual Cinco de Mayo parade and Fiesta Mexicana.

Although popular in the United States, Cinco de Mayo is not a major holiday in Mexico. September 15 and 16 are Mexico's independence day(s). Patriotic festivities were usually led by the Mexican consul. One of the highlights was the coronation of the Queen of the Fiestas Patrias (Patriotic Festivities), usually at large venues downtown like the Veterans Memorial Building. The first celebration of this kind was planned under the direction of the Mexican Honorary Commission led by Consul Terrazas in the late 1920s.

In 1968, Fr. Clement Kern helped put together a 17-member Latino clerical and lay team that founded Latin Americans for Social and Economic Development (LA SED) in 1971. Other nonprofit social agencies were initiated in the 1960s. Club Mexico, the first all-Mexican soccer team, was started in the early 1960s.

In 1936, Jose Alfaro, charismatic owner of a printing company and newspaper, started a weekly radio program. Alfaro had musicians performing live on his show. *El Grito de mi Raza* had a long run at WDET-FM but disappeared in a management/format reshuffle. Another long-running radio program was hosted by "La Guerita de Oro," Olivia Galan, who also owned a nightclub in Luna Pier, Michigan. Today, La Explosiva 1480 AM, led by Alejandro Resendez, broadcasts daily.

The first community newspaper was *El Camello* in 1928. *La Gaceta Mexicana* and *Prensa Libre*, published by Luis G. Gasca, followed. Gasca was a freethinker at odds with the church. In response, the very Catholic *La Chispa* began publication in 1930. Gasca returned to Mexico during the Repatriation. There were seven other newspapers printed between 1933 and 1961, all Mexican-owned. They failed due to lack of support from the community. Now, there are several Spanish-language and bilingual newspapers. Dolores Sanchez's *El Central* and *Latino Press*, owned by Elias Gutierrez, a Chilean, are the most successful.

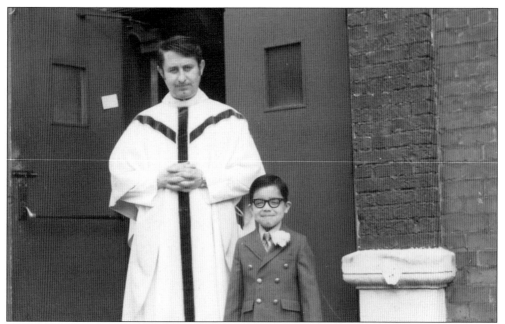

Most Holy Redeemer Church had an annex chapel located in Delray. It was located on West Jefferson Avenue, near historic Fort Wayne. Felipe Perea made his first Holy Communion at the annex, partially because his older sister attended high school at Holy Redeemer and learned that the annex was near their home. (Author's collection.)

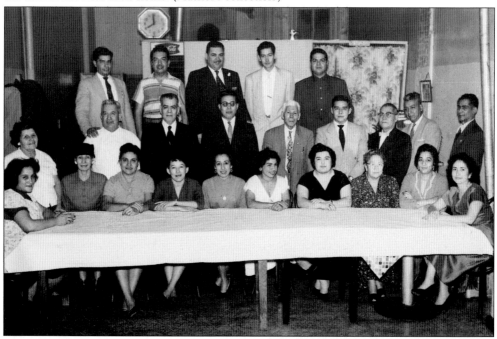

Mary Segura (first row, sixth from the left) was active in several social organizations in the Mexican community, including the Caballeros Catolicos. They purchased and rehabbed their own hall on Bagley Avenue. In the mid-1960s, the organization dwindled to a point where it was disbanded. Subsequent attempts to reform the group were unsuccessful. (Courtesy of Mary Segura.)

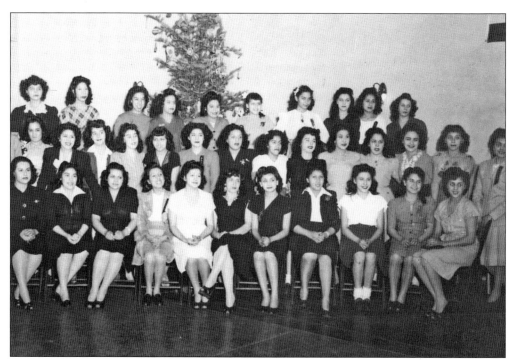

Many social organizations were exclusive to men or women. Casa Maria hosted many events for young ladies at its hall on Trumbull Avenue near Most Holy Trinity. (Courtesy of Mary Segura.)

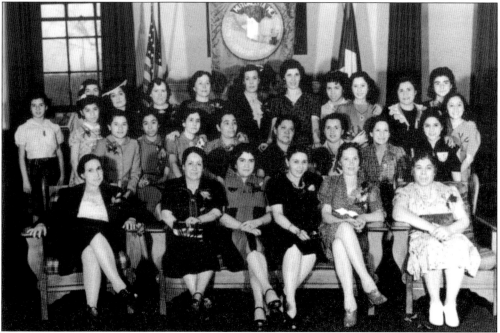

The Circulo Mutualista de Detroit, a family oriented organization, met to speak Spanish, organize dances, and hold pot luck suppers in order to socialize. Librada Macias (second row, second from right) was married to Vicente Macias, president of the organization. Trinidad Alvarez (first row, far right) is the author's grandmother. (Courtesy of Ray Lozano.)

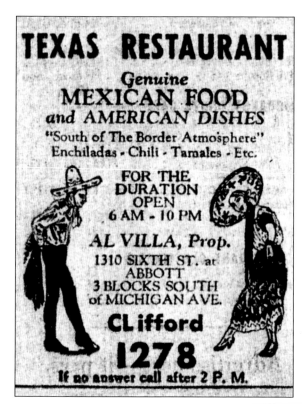

Texas Restaurant was a popular brunch spot after mass at Most Holy Trinity, a block away on Sixth Street. The restaurant no longer exists. Many still have fond memories of these pioneer restaurants and businesses. (Author's collection.)

The Corktown Dancers and the Instituto de Cultura Hispano Americano presented one of the founding members, Carmen Cortina, with an Anniversary Award. This photograph was taken in 1962. (Courtesy of Dr. Lucile C. Gajec.)

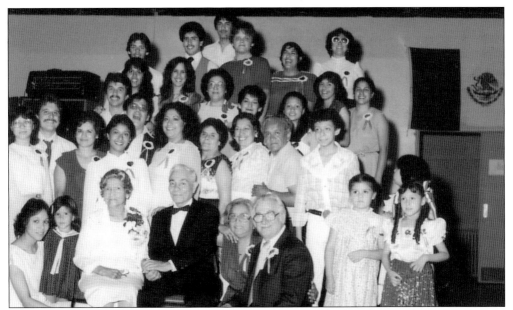
Carmen and Norbert Cortina (seated, center) and Luci and Edward Gajec (seated, right) are surrounded by past and present folkloric dancers. Parents did more than commit time to take their children to practice. They traveled extensively throughout the region so that their children could perform. The families were so proud to share the culture with the mainstream community that no fee was ever charged for their performances. (Courtesy of Dr. Lucile C. Gajec.)

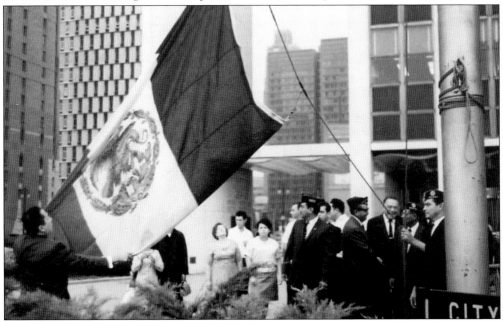
A Mexican flag-raising ceremony takes place on West Jefferson and Woodward Avenues next to the City County Building (now the Coleman A. Young Municipal Center). This was the culmination of the many festivities that surrounded the holiday. This event was organized by Mexican American Post No. 505, the Mexican Patriotic Committee, and the consul of Mexico. (Courtesy of Dr. Lucile C. Gajec.)

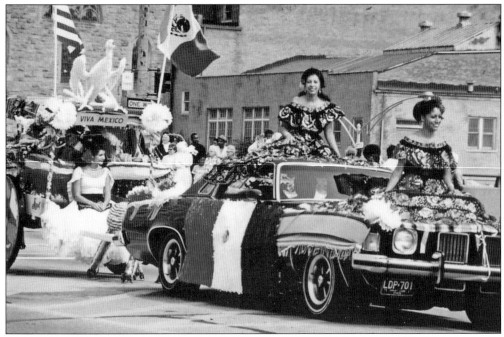

In the early 1970s, the Mexican Independence parade took place on West Jefferson Avenue near Woodward Avenue. These floats and cars were all decorated by volunteers and the families of the participants. This particular float carries the regal court. (Courtesy of Dr. Lucile C. Gajec.)

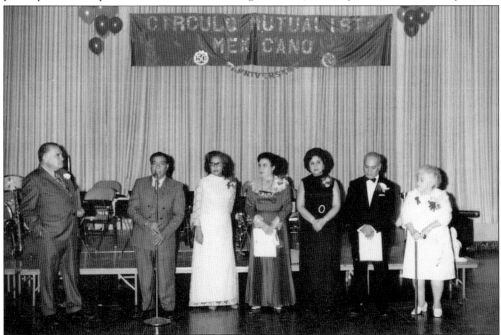

In 1972, the Circulo Mutualista Mexicano celebrated its 50th anniversary by recognizing the leaders and volunteers who founded and built the organization. Pictured from left to right are Jose Alfaro, Angel Cornejo, and Luci Gajec presenting the awards. Among the awardees are Rita Solis (third from right) and Antonio Alvarez (second from right). (Courtesy of Dr. Lucile C. Gajec.)

Pictured here from left to right are Margarita Torres, international celebrity Johnny Canales, Teresa Cornejo, and Angel Cornejo. In 1989, the three day Fiesta Mexicana was at Hart Plaza. It was organized by the Comite Patriotico Mexicano. The venue has an amphitheater that seats 2,000. Many times it was standing room only. In addition to the main theater, there was the Pit theater with non-stop entertainment from 11:00 a.m. to 11:30 p.m. It was the only time of the year when you could sample Mexican delicacies not found at the local restaurants. (Author's collection.).

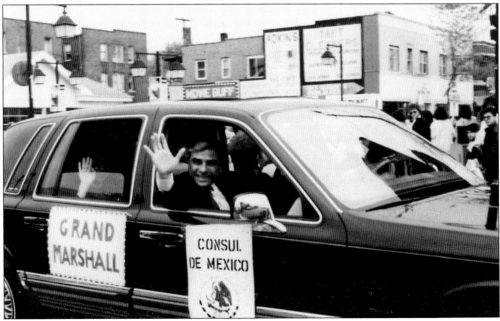

The Mexican government always had a presence at Mexican patriotic events. In 1989, Consul Jose Mendoza Caamaño was grand marshal for the Cinco de Mayo parade on West Vernor Highway in Southwest Detroit. (Author's collection.)

In 1824, consular services were provided to Mexican residents living in Michigan and Ohio by the general consulate office established in New York City. In 1920, with the Mexican population substantially increased, a consulate of Mexico opened in Detroit. By 1940, the Detroit office was under the jurisdiction of the consul general of Mexico in Chicago. Maria Elena Rodriguez (left), Consul Antonio Meza Estrada (center), and Max Rodriguez are pictured. (Author's collection.)

The current consul of Mexico, Vicente Sanchez Ventura (left), and Florencio Perea attend the 2006 ribbon-cutting ceremony of the Mexicantown Welcome Center and Mercado. Ventura is the 24th consul to serve the Mexican community in Detroit. The needs of the Mexican community are greater than ever, and services have expanded since the consulate doors opened in 1920. (Author's collection.)

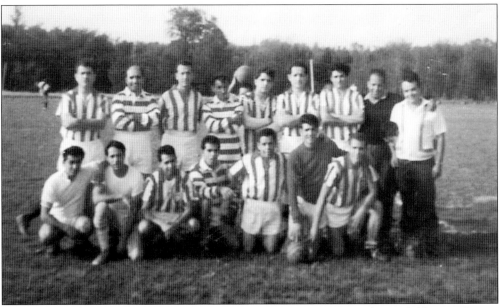

In 1964, Club Mexico was the only Mexican soccer team in Detroit. Its home field was at Patton Park. The team played in a league that included European American teams from around Metro Detroit. At the far right, Florencio Perea, the author's father, stands with his team. (Courtesy of Florencio Perea.)

A view from the Holy Redeemer bell tower at Junction Avenue and West Vernor Highway shows how the corner has changed over the years. The insurance office across from the flag was formerly a Cunningham drugstore. Some businesses have moved out and been replaced with check-cashing businesses, clothing stores, and barbershops. (Author's collection.)

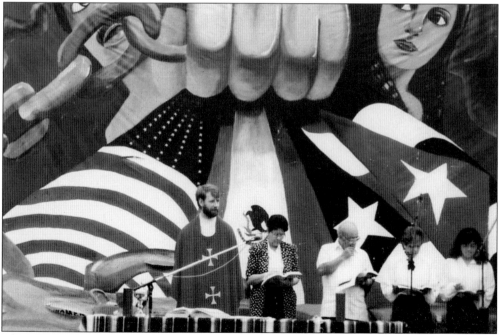

The iconic backdrop for Casa de Unidad's Unity in the Community Festival reflected all of the cultures that make up southwest Detroit. The weekend festival was a celebration of art, music, traditions, and distinctive foods from various countries. The final day always started with an open-air mass. (Author's collection.)

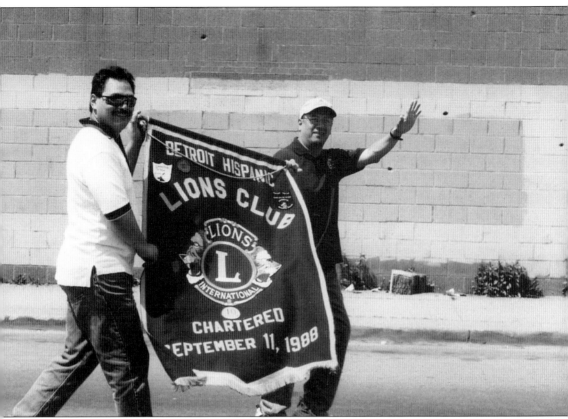

Although Mexicantown prides itself on keeping traditions alive, it is also a place that embraces innovation, new leadership, and organizations. The Detroit Hispanic Lions Club was established in 1988 and does good work in Detroit. (Author's collection.)

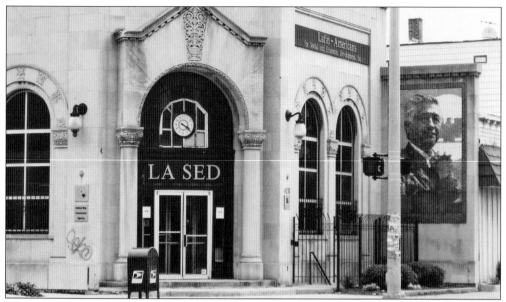

Latin Americans for Social and Economic Development, better known as LA SED, was established in 1968 and is the oldest community social-service agency. Its main building is located on the corner of West Vernor Highway and Scotten Street, across the street from Clark Park. LA SED also has a community center on West Vernor Highway at Green Street that provides services for seniors and youths. Over the years, LA SED has been a first stop for those in need. Budget cuts and economic downturns have affected service delivery in southwest Detroit. Through it all, LA SED has remained open and continues the mission of serving the entire community. (Author's collection.)

In 1970, Community Health and Social Services, better known as CHASS, opened an office on West Vernor Highway next door to Holy Redeemer's gym. Since then, CHASS has provided quality, affordable, "cradle-to-grave health care" for all. To accommodate more patients and improve service delivery, CHASS moved one mile south to West Fort Street and Junction Avenue. In its 40th year, CHASS began building a new 48,000-square-foot facility adjacent to the current clinic that will triple space and further enhance services. Led by longtime CEO Ricardo Guzman, CHASS is considered a national model for community-based health care. (Author's collection.)

Six
Arts and Culture

Mexico has a long tradition of incorporating art into everyday life, and Mexican immigrants brought an appreciation for public art to Detroit. The drive to maintain values, traditions, and culture impacted most community events. Social organizations hosted large Christmas functions for children and families. Live musical performances and dramatic presentations were key elements at Mexican patriotic festivities attracting thousands of people.

Raices Mexicanas, Telpochalli, Baile Folklorico de Corktown, and Baile Folkorico Mayahuel are just a few of the folkloric dance groups. They were for many years the main vehicle for transmitting and sharing culture. Maria Alcala and Carmen Cortina were early leaders in what became a folkloric dance movement. The author founded and led Telpochalli in the 1970s. Raices Mexicanas was started in 1980 at Ste. Anne's Church by Herminio Pesina. Herminio was 14 at the time. Led by Cristana Huizar, the group competed internationally and performed at the first Cinco de Mayo event at the White House, hosted by Pres. George W. Bush.

Over the years, a number of cultural organizations grew around Mexicantown and southwest Detroit. Casa de Unidad, once located on Scotten Street at West Vernor Highway, hosted "Unity in the Community," a popular summer festival that celebrated Mexican and all of the cultures evident in southwest Detroit.

By the late 1990s, there were over 25 cultural organizations in southwest Detroit, more than any other residential part of the city. Compas is an emerging organization of artists with a cultural center that offers a variety of classes from flamenco dance to music for children at the old Odd Fellows Hall on West Vernor Highway. The Matrix Theatre is another example of community-based art.

Vito Valdez and Hector Perez are just two of a larger group of visual artists that resided in southwest Detroit. Perez had a huge impact on his students in his art classes at Amelia Earhart Middle School. He taught his mostly immigrant students the importance of Mexican folk art and connected them to their heritage through art. He has a large following and has been commissioned to create some outstanding Mexican skeletons in every medium. He and his family are now living in Hawaii. Steve "Pablo" Davis painted the bottom squares of the Diego Rivera mural at the Detroit Institute of Art and lived for many years in southwest Detroit. He taught art at Academia de las Americas as well, and was the driving force for the Pablo Davis Elder Living Center in Patton Park.

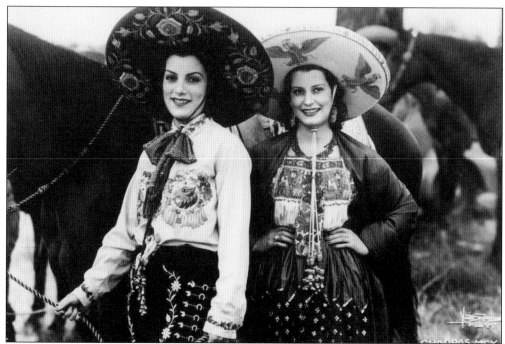

This postcard, dated 1937, illustrates traditional Mexican craftsmanship. (Author's collection.)

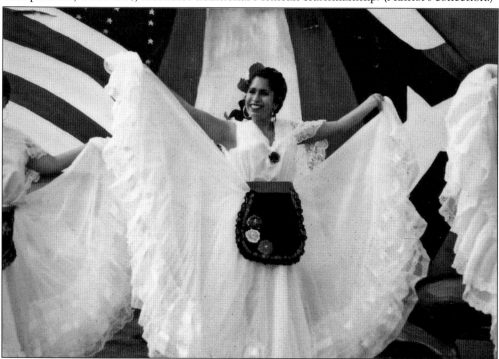

Cristina Huizar, director/instructor of Raices Mexicanas, a Mexican folkloric dance group housed at Ste. Anne's Church, is seen at a performance at the Unity in the Community Festival at Clark Park. In 2001, Raices Mexicanas performed at the first White House Cinco de Mayo celebration. (Author's collection.)

This image is of a town in the highlands of Puebla, Mexico. Immigrant workers forced to leave towns like this remain connected through satellite TV and other modern technologies. (Author's collection.)

Olivia Galan, better known as "La Guerita de Oro" (right), hosted a popular Spanish-language radio program that ran for many years on WMZK 98 FM. She also promoted live entertainment at her nightclub in Luna Pier and Tenampa on Bagley Avenue. El Zocalo restaurant is now where the Tenampa used to be. The many local radio programs throughout the years include Una Serenata de Mi Barrio (A Serenade of My Neighborhood), Mejico Musical (Musical Mexico), and El Grito de Mi Raza (The Cry of My People). Today, the most popular radio program is directed by activist Alejandro Resendez at 1480 AM, La Explosiva, or laexplosivadetroit.com. (Author's collection.)

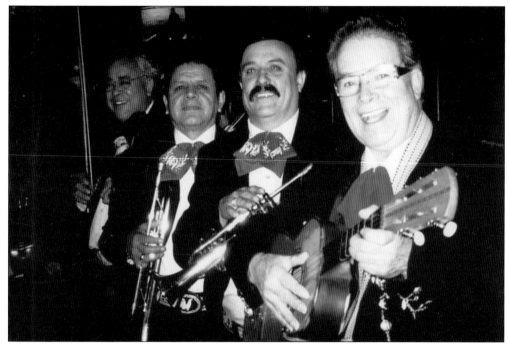

Raul Hernandez (far right) led Mariachi Especial, one of four mariachi groups in Detroit. Especial was highly regarded because of its tight, professional sound. Most of its members are from Jalisco, where the mariachi sound originated. Today, there are fewer mariachi groups in Detroit and a need to teach young people the music. Mariachi Cora has done just that. One of its regular musicians is a young lady who the group trained. (Author's collection.)

In the late 1980s, explosive growth created a demand for news sources. Dolores Sanchez founded *El Central* newspaper. It is bilingual and widely distributed. In the early 1920s, there was not enough readership to support *El Eco de la Patria* and other attempted newspapers. Today, several publications circulate in Michigan, including *Latino Press* and *Mi Gente*. *Mi Estilo* is an online bilingual magazine. (Author's collection.)

Salvador Torres is a local recording artist and 1986 Grammy nominee for his composition *Unidos Cantemos*, a song dedicated to the victims of the devastating 1985 Mexico City earthquake. A local celebrity, Salvador continues to perform with his mariachi group. (Courtesy of Sally B. Ramon.)

Lydia and Richard Gutierrez are the founders of Hacienda Foods, a tortilla-manufacturing company. Richard's family opened La Michoacana, the first *tortilleria* in Detroit. After many years at the family business, Richard and Lydia started their own. Hacienda Foods makes corn products, including chips, and imports Mexican food products for a large customer base. (Author's collection.)

The Gutierrez family believes that public art is a way of connecting with the community and improving business. They commissioned two murals that cover each side of their original building at West Vernor Highway near Cavalry Street. They were spray-painted by Chilean artist Dasic Fernandez. (Both, author's collection.)

Seven
REVIVAL

Mexicantown experienced setbacks in the late 1960s and early 1970s. The most significant was the I-75 freeway bisecting the community from Delray past the Ambassador Bridge. By the mid-1980s, the Michigan Department of Transportation and the Detroit International Bridge Company were buying homes and businesses. The community began to see a pattern of entire blocks of the neighborhood vacated for "future use." A blighted image affected everyone living in the area and welcomed visitors crossing the border from Canada. In 1989, Mexicantown Community Development Corporation (MCDC) was created to build upon the remaining assets of the neighborhood—mostly Mexican restaurants and stores—and to form a strong coalition of interests. In its first five years of operation, MCDC increased patronage at local restaurants by 65 percent.

There was an interest in rebuilding the Hubbard Richard district surrounding Ste. Anne's Church, and new housing began to appear. There are new condominiums and a senior housing complex just across the street from Ste. Anne's—all built by Bagley Housing Association. Housing construction is a good sign that the community is again becoming family-friendly.

A trend began in the early 1990s, when the first authentic taqueria (home-style), La Tapatia, opened on West Vernor Highway. Now southwest Detroit has over 30 taquerias. Surprisingly, they all do well. The same can be said of the new small businesses that have opened in Mexicantown and southwest Detroit.

The revival also caught the attention of large Hispanic-owned automotive suppliers who were based in the suburbs. Thanks to the encouragement and example of former Detroit Tiger and owner of Mexican Industries Hank Aguirre, Ric Gonzalez, Facundo Bravo, Carmen Munoz, and Frank Venegas opened the Hispanic Manufacturing Center at an old GM plant on Clark Street. They immediately hired local residents and young adults. This added a real sense of hope to a neighborhood working hard on making a comeback.

The variety of nonprofit organizations that has been driving the revival includes human service, housing, economic development, and art-based organizations. Residents and stakeholders have invested time, money, and sweat equity in Mexicantown. It is evident to any visitor.

Tamaleria Nuevo Leon, located on West Vernor Highway and St. Anne Street, has been in the same spot since the 1950s. Being on the east side of the I-75 freeway construction clearly challenged the Villarreal family and the viability of their business. They have managed to thrive over the years by producing great tamales and maintaining a loyal customer base. (Author's collection.)

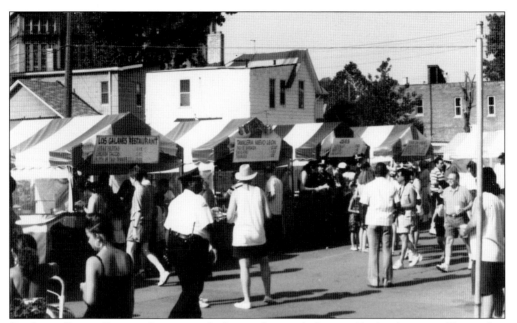

Southwest Detroit Business Association had a riverfront-style fiesta on Bagley Avenue at Twenty-first Street. All of the local restaurants participated, and it was a great success. Similar events continued until sponsors recommended that the Mexicantown Community Development Corporation construct a permanent location. MCDC accomplished that, building up the customer base for the businesses located in the historic Bagley Avenue district. (Author's collection.)

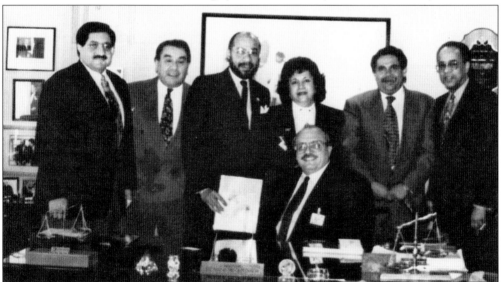

In 1996, four entrepreneurs opened the Hispanic Manufacturing Center at the former General Motors Cadillac plant on Clark Street just south of Michigan Avenue. The Hispanic Manufacturing Center continues to operate and provide steady work to local residents, who can walk to their jobs. HMC has helped stabilize its surrounding community. From left to right are Ignacio Salazar, CEO of Ser Metro; Facundo Bravo, CEO of Uniboring; Mayor Dennis Archer; Carmen Munoz, CEO of Munoz Machine Products; Frank Venegas, CEO of Ideal Group; Deputy Mayor William Beckham; and, seated, Ric Gonzalez, CEO of Gonzalez Design Group. (Courtesy of Ideal Group.)

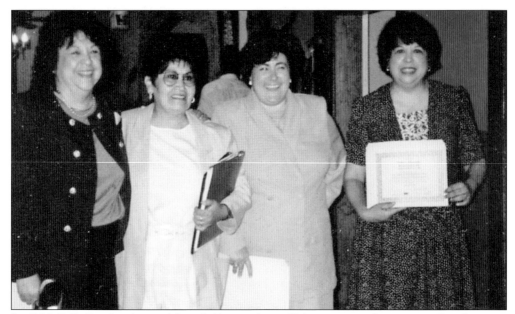

In 1996, Sally Rendon (second from left), president of Mexicantown Community Development Corporation, began offering entrepreneurial training to local residents interested in starting a small business. The program was serviced by the Michigan Small Business & Technology Development Center. Two graduates, Dulia Hernandez (right) and Lidia Medina (left), went through the program and obtained microloans from one of the local banks. (Author's collection.)

At a 1998 holiday event, Maria Elena Rodriguez was announced as the new president of Mexicantown Community Development Corporation, and Sally Rendon moved on. Expectations were high, and there was a real sense of revival in southwest Detroit. This particular event was organized by Martina Guzman, an extraordinary woman whose parents are from Jalisco, Mexico. She is an entrepreneur, public radio journalist, and documentarian. She is making a huge contribution to Detroit. Pictured are Maria Elena Rodriguez (left) and Martina Guzman. (Author's collection.)

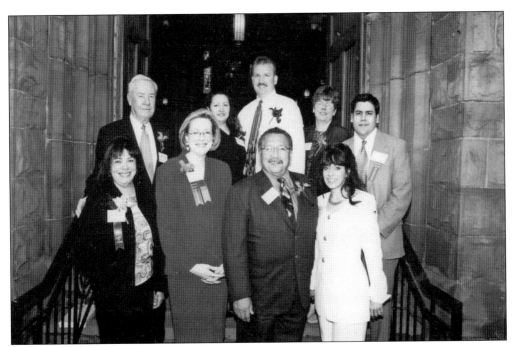

The 2001 Community Investment Breakfast that took place at Ste. Anne de Detroit is an annual event that honors individuals and institutions that invest in southwest Detroit. Pictured are, from left to right, (first row) Maria Elena Rodriguez, president of MCDC; Kathleen Wendler, president of SDBA; Jose Puente, Detroit Edison; and Lydia Gutierrez, chair of SDBA and CEO of Hacienda Foods; (second row) Leocadio J. Padilla, president of Commerce Industrial Controls; Tomasita Alfaro-Kohler and her husband, Ken Kohler, owners of La Colmena (Honey Bee) market; a representative of Edw. C. Levy Co.; and Hector Hernandez, MCDC board chair. (Author's collection.)

In addition to the Mexican restaurants that established themselves on Bagley Avenue and Vernor Highway, there is one restaurant that offers a combined Mexican and Central American menu. Family-owned El Comal has been in southwest Detroit for over 20 years. The Castellano family is from Guatemala and part of the growing Latino diversity in southwest Detroit. (Author's collection.)

This is a view of the original Mexicantown restaurant district on Bagley Avenue just west of I-75. Xochi's gift shop, Taqueria Lupita, and Mexicantown Restaurant are popular stops for Mexican food and shopping. (Author's collection.)

El Zocalo is one of the Mexican restaurants located on Bagley Avenue west of I-75. The building was originally a bank and then the Tenampa night club before it became a restaurant. Victor Cordoba, originally from Costa Rica, and his family own this popular restaurant. (Author's collection.)

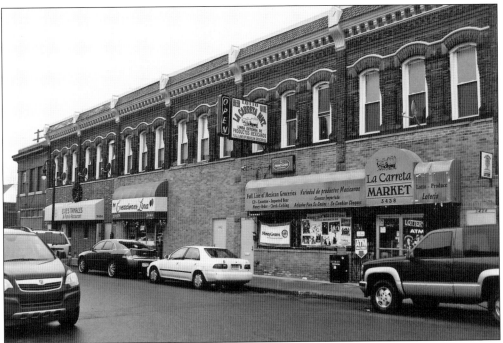

Evies Tamales is a popular spot for tamale fans. Creaciones Lina, La Carreta Market, and La Michoacana tortilla manufacturing plant are located in the original Mexicantown district on Bagley Avenue west of I-75. This block is always busy with loyal customers. (Author's collection.)

La Gloria Bakery is a traditional Mexican bakery making pastries, tamales, and seasonal items in-house. It is another example of a family business that has survived freeway construction. (Author's collection.)

Xochimilco is a Detroit landmark. The Morales family created a popular restaurant where people line up even in the wee hours of the morning. The Moraleses also own most of the real estate on their block. (Author's collection.)

Los Galanes Restaurant has evolved from one small building to a tripling in size and the addition of a large banquet facility on its second floor. The children of the owners have opened restaurants in Detroit's suburbs. (Author's collection.)

This is a view of the housing just north of West Vernor Highway and west of Junction Avenue. The storefronts that line West Vernor Highway include national franchises like Payless Shoes. (Author's collection.)

Armando's Restaurant, located just a few blocks west of the Mexicantown/Bagley Avenue restaurant district on West Vernor Highway, was originally owned by Armando Galan of Los Galanes. He sold it to the Hernandez family. They later opened the bakery next door. Originally from Cuba, the Hernandezes have successfully run both their restaurant and bakery for many years. (Author's collection.)

The Mexicantown Bakery has been a success since its opening. The Hernandez family had been bakers long before getting into the restaurant business. They make and sell traditional Mexican baked goods and offer Caribbean and Mexican groceries. They operate a graphic design studio on the second level of this fully restored building. (Author's collection.)

In 1983, the Avila family decided to start a business. While working full-time at his other job, Alfonso Avila and his wife developed a restaurant offering home-style Mexican dishes from their native San Luis Potosi. El Rancho has done very well. The Avila children, now all college graduates, worked at or managed the family business at different points in their lives. Their strong commitment to quality and tradition makes El Rancho a favorite place for local families in southwest Detroit. (Author's collection.)

Taqueria Mi Pueblo, located in southwest Detroit, is closer to Dearborn than to the heart of Mexicantown. Jesus Lopez started his business in his home and used his construction skills to expand and upgrade. The restaurant offers authentic cuisine from the state of Jalisco and is now almost four times its original size. It was one of many taquerias that began to open in southwest Detroit in the 1990s. There are now over 35 taquerias in Mexicantown, southwest Detroit, and the Detroit suburbs. Mi Pueblo's quality and authenticity have earned it a huge Mexican and non-Mexican customer base. (Author's collection.)

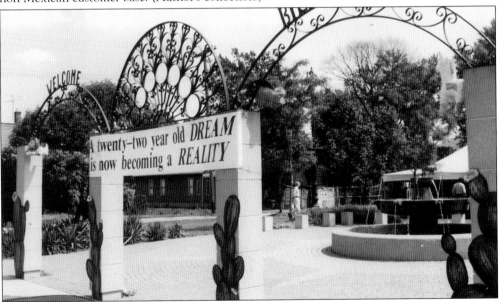

Fiesta Gardens was built with a traditional fountain and wrought iron arches made by Tony Martinez of Disenos Ironwork. This location on Bagley Avenue between Twentieth and Twenty-first Streets was selected as the future site for the International Welcome Center. These plans were finalized after years of freeway construction and the transportation industry buying and occupying most of the local property. (Author's collection.)

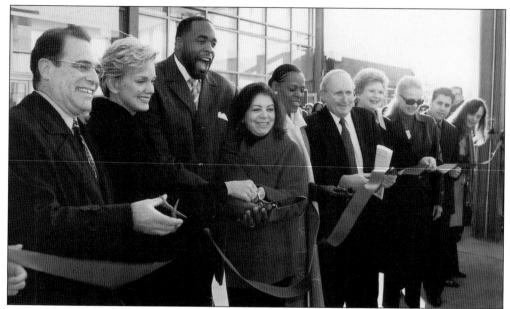

On October 26, 2006, Detroit celebrated the opening of the Mexicantown International Welcome Center and Mercado. Cutting the ribbon for this important project are, from left to right, Robert Ficano, Wayne County executive; Gov. Jennifer Granholm; Detroit mayor Kwame Kilpatrick; Maria Elena Rodriguez, president of Mexicantown Community Development Corporation; Congresswoman Caroline Cheeks Kilpatrick; US senators Carl Levin and Debbie Stabenow; Fern Espino, chair of Mexicantown CDC; Hector Hernandez, chair emeritus of Mexicantown CDC; and Margaret Garry, vice president of Mexicantown CDC. (Author's collection.)

The view of the Ambassador Bridge from the Mexicantown Mercado on Bagley Avenue is a visual tribute to the determination of a community to build something distinctive and elegant to serve as a backdrop for future development and welcome visitors from around the world. (Author's collection.)

Eight
LATEST CHALLENGES

The few Mexican families who settled in Detroit in the 1920s would have never imagined that thousands of other families would follow by the year 2000. They would not have thought that by the 1990s, Mexicantown would be the only area experiencing growth in Detroit.

Mexicantown and Detroit face great challenges. Since it lies at a hub of highways and international trade routes, Detroit's Mexican community presents opportunities for community builders and commercial interests. Perhaps its greatest challenge in a post-9/11 era is in dealing with the fear and division wrought by the new Department of Homeland Security agenda. This translates into a need for stakeholders, residents, and business people to work together to make sure that the neighborhood is safe and that city services match the area's commercial impact. There is a need for unity and strength to prevent becoming just one large backdrop for the transportation industry.

Local leaders like Kathleen Wendler understood this back in the mid-1970s. Since then, she has worked through the Southwest Detroit Business Association (SDBA) to strengthen the commercial life of the area. In the late 1990s and at the turn of the new century, SDBA and the Mexicantown Community Development Corporation fostered a sustained period of small business growth and development. The work of these two sister organizations helped the community weather the economic downturns of the recent recession.

MCDC designed and built the Mexicantown Welcome Center and Mercado. At first hailed as the culmination of a 30-year dream, the project has fallen on hard times. It stands ready for occupancy on the east side of I-75 and at the east end of the new pedestrian footbridge reconnecting Bagley Avenue. It exists as a symbol of Mexicantown's drive and sustainability in a city struggling to find its way.

Mexicantown persists. People still come to live, work, and play there. Longtime merchants have held on despite two-year freeway shutdowns and the noise and dust of construction. People continue to visit Mexicantown. Every Sunday, the faithful stream into its churches. Afterwards, they purchase their groceries or stop to eat, continuing the routines and rituals of those first Mexican families.

The Mexicantown International Welcome Center and Mercado on Bagley Avenue and 21st Street offers a destination site for Detroit. A pedestrian bridge crossing I-75 is now in place, encouraging visitors to enjoy both sides of a formerly divided business district. The challenge will be to bring together a mix of tenants to enhance the branding from earlier years. (Author's collection.)

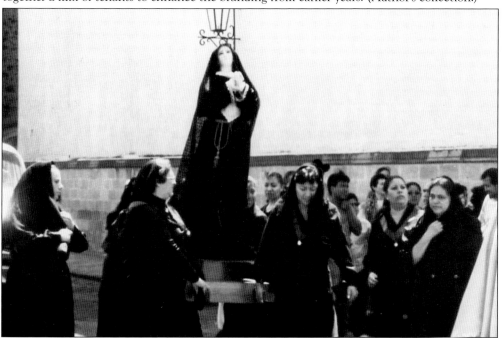

Processions and pageantry are an important part of Mexican culture. This is Holy Saturday in Queretaro, Mexico. The women belong to an altar society and have the privilege of carrying a 17th-century statue of Our Lady of Sorrows through the streets of Queretaro and back to the Sanctuary of the Holy Cross. Holy Week is a solemn yet colorful occasion. Queretaro and other Mexican cities that maintain these traditions draw huge numbers of devotees. (Author's collection.)

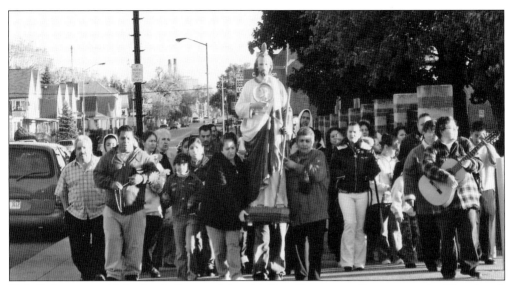

Holy Redeemer parish is a key indicator of the viability of its surrounding community. The church has been sensitive to the changing needs of its members. Expanding community services in Spanish, scheduling more than one mass in Spanish, and encouraging new parishioners to bring their traditions to Detroit would have been discouraged and resisted 40 years ago. This procession is led by a group of devotees of San Judas Tadeo (St. Jude Thaddeus) carrying his statue. The group raised money to purchase the statue in Mexico and brought it to Holy Redeemer Church. (Author's collection.)

On March 17, 2005, the Archdiocese of Detroit announced that 18 Catholic schools would close at the end of the school year because of low enrollment. Holy Redeemer High School was closed. Because of their tenacious commitment to continue to educate local children, the Immaculate Heart of Mary Sisters and Basilian Fathers at Holy Redeemer did not give up. After lengthy negotiations in the late summer of 2008, Cristo Rey High School opened its doors at the former Holy Redeemer High School building. This photograph shows Alyssa Avila and Martin Escobedo, members of the class of 2013. (Courtesy of Detroit Cristo Rey High School Collection.)

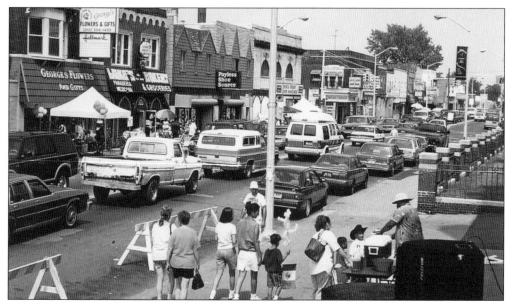

The latest challenge for Detroit's Mexican community is maintaining the viability of its businesses, services, and institutions. The Mexican families who settled in Detroit and opened a few businesses on Bagley Avenue back in the 1930s could never have imagined the over 1,000 businesses now operating within a three-mile radius. All essential needs—from accounting, legal services, dental/medical, and so forth—can be met in southwest Detroit. Almost all of the businesses are family-owned and contribute to Michigan's economy. (Author's collection.)

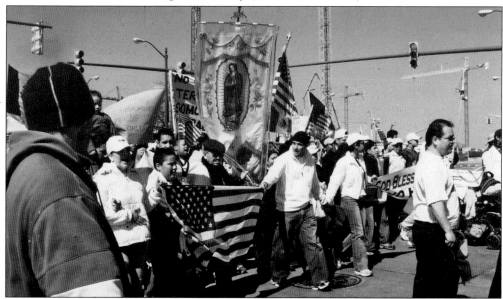

The revival of southwest Detroit, with an increased housing value and a thousand new businesses, is largely due to Mexican families moving in. This scenario repeats itself throughout the United States—expanding the need for comprehensive immigration reform. As a result of growing frustration, demonstrations took place on March 25, 2006, in many American cities. Detroit had over 10,000 people march peacefully from the doors of Holy Redeemer Catholic Church to the federal courthouse in downtown Detroit. (Author's collection.)

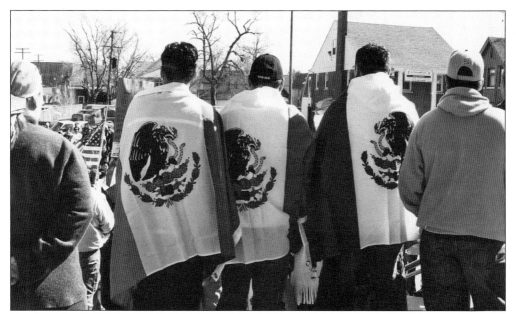

On that March 25, there was a unity never seen before in the Mexican community. Seniors who came to Detroit in the 1940s and 1950s, with their children and grandchildren, all-American citizens, marched with the new immigrant families. The thousands of new faces and families were all united by a common history and faith. A great sense of pride in tradition and origins is combined with a fierce loyalty to their new home and country. (Author's collection.)

In 2009, Msgr. Donald Hanchon, pastor of Holy Redeemer Church and now an auxiliary bishop in the Archdiocese of Detroit, officiated a communal wedding of seven Mexican couples. Most, if not all, of the couples were already married through civil law, but for one reason or another had never made it to the altar. There was a small reception in the Blue Room, and each couple received a wedding cake and a toast to a life together. (Author's collection.)

Isela and Ricardo Patino were joined in holy matrimony in May 2009. They were married for 10 years but decided to sanctify their marriage by participating in a communal wedding. They had a family reception in Allen Park, Michigan. (Author's collection.)

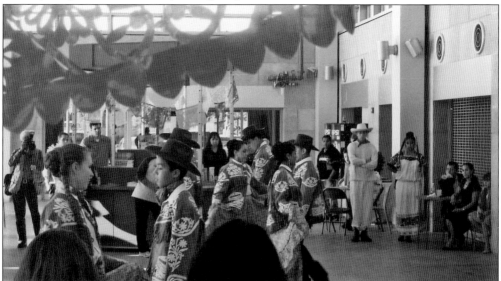

How to harness the vibrancy that this community creates and shares with the region and how to impart to the greater community an understanding that the Mexican immigrant has been and will continue to be an asset for Metro Detroit and the rest of Michigan are important issues. The values of faith, strong families, and a stronger work ethic are Mexicans' priceless contributions to this country. Like the many ethnic groups who contributed to Detroit's growth and history, Mexicans come north seeking a better quality of life for their family and themselves. This is the rock upon which a common American Dream is built. (Author's collection.)

Bagley Avenue, once known as La Bagley, was the heart and soul of the Mexican community's business district. Today, it is also a gateway from the US to Canada symbolized by these flags on Bagley at Twenty-first Street on the east side of the I-75 freeway. (Author's collection.)

The pedestrian bridge that connects both sides of Bagley Avenue was once the site of a Mexican movie theater named the Alamo. Other businesses were also there. Sylvia Salmon Ross best described her neighborhood: "It's where Roy the waffle man used to come by and sell his goodies. You could shop at the five-and-ten store, the Ruth and Art Grocery store, and Willis's Used Furniture Store. It's where a man on a horse-drawn cart would pick up your junk and recycle it. It's where houses were actually built next to and under the Ambassador Bridge." These places are long gone, but the essence of that community lives on through new families and the businesses that have never stopped coming to Detroit. (Author's collection.)

www.arcadiapublishing.com

Discover books about the town where you grew up, the cities where your friends and families live, the town where your parents met, or even that retirement spot you've been dreaming about. Our Web site provides history lovers with exclusive deals, advanced notification about new titles, e-mail alerts of author events, and much more.

Arcadia Publishing, the leading local history publisher in the United States, is committed to making history accessible and meaningful through publishing books that celebrate and preserve the heritage of America's people and places. Consistent with our mission to preserve history on a local level, this book was printed in South Carolina on American-made paper and manufactured entirely in the United States.

This book carries the accredited Forest Stewardship Council (FSC) label and is printed on 100 percent FSC-certified paper. Products carrying the FSC label are independently certified to assure consumers that they come from forests that are managed to meet the social, economic, and ecological needs of present and future generations.

FSC
Mixed Sources
Product group from well-managed forests and other controlled sources

Cert no. SW-COC-001530
www.fsc.org
© 1996 Forest Stewardship Council

Find Your Place in History.